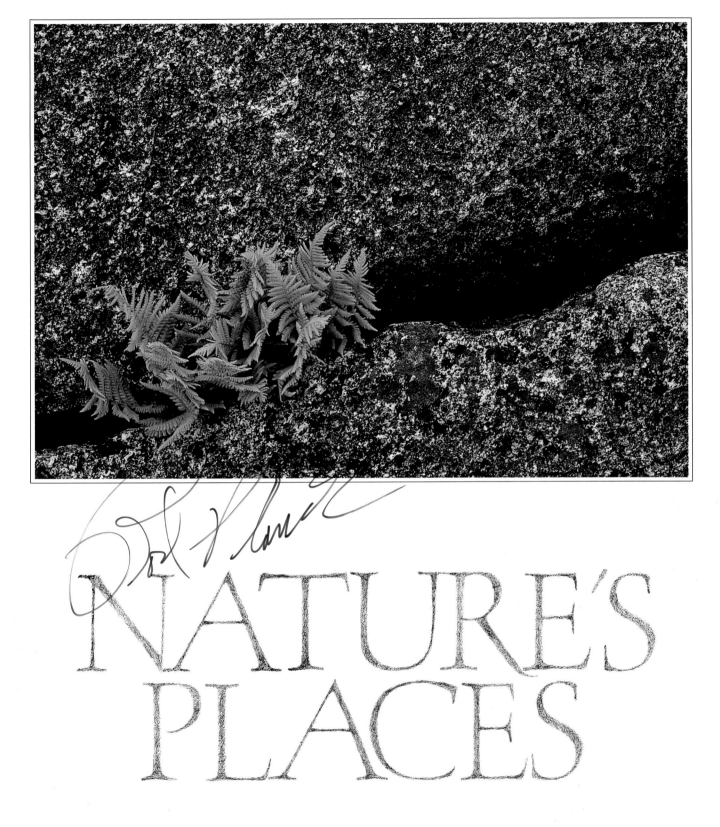

NATURE'S PLACES

PHOTOGRAPHY BY ROD PLANCK

TEXT BY BERT C. EBBERS

This book is dedicated to my late uncle Burt,

who helped teach me the special ways of nature,

and to my children, Anne and Dylan,

who I hope will carry the message forward in their own ways.

B.E.

ACKNOWLEDGMENTS

No project can ever come to fruition through the sole effort of a single person; thus we would like to thank the following people who have contributed through technical or personal support: Bradford Frye and Robert Mack (Capitol Reef National Park), Nora Deans and Michael Rigsby, Ron and Sharron Smith, Larry Tracy and Larry West.

Special Acknowledgment: David and Mary Slikkers, their unfailing support and effort kept this project on course.

To Marlene: Thank you for all your love throughout the years.
Your intellect and hard work have made this dream become a reality.

R.P.

ISBN # 0-9634200-4-6

Library of Congress Catalog Card Number 92-73971

10 9 8 7 6 5 4 3 2 1

Inside front cover: Lupine, Alaska
Inside back cover: Yellow-headed blackbird, Colorado

Published by

Hawk-Owl Publishing
P.O. Box 140
Hubbard Lake, Michigan 49747

Project Coordinator: Marlene Planck
Book Editor: Kathryn E. Parker
Design: Carole Thickstun and Lawrence Ormsby
Typography: Andresen Graphic Services, Tucson
Printing coordination: Bobbi Williams, Andresen Press, Tucson

CONTENTS

Nature is full of special places, from microcosms of wildness in city parks to the immense open space found in less-developed parts of the world. "Place" is typically associated with a particular geographical setting, but it also can be thought of in terms of the individual components of the setting, as well as an interval of time.

For example, a vernal woodland pond in Michigan is a distinct place, as is a mallard that returns there each spring with others of its kind, to carry on the rites of courtship. One can expect their excited gabbling to be drowned

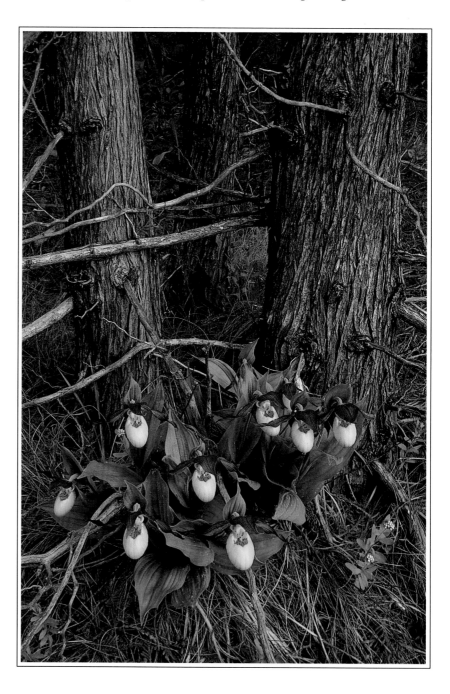

Small yellow lady's-slipper, Michigan

out periodically by a rising crescendo of spring peepers and wood frogs. This is a time of year when woodcocks dance nightly, and the leaf litter crinkles, pushed madly upward by earthworms re-surfacing for the first time since autumn past. Mallards and frogs are as much the pond as the pond itself, and woodcocks and worms are as much the woods as the woods itself. When the pond dries up, the mallards and frogs disperse, and the bare mudhole changes into a verdant meadow. However, memories linger, and the spring peeper found hiding under your doorstep in mid-summer may be one of the many you heard in April, when it was warm again at night and you lay in bed with the windows open, listening to the frogs and the woodcock and the rest of the world springing to life.

Nature's special places are an integral and important part of my life, as well as Rod's. Rod and I are friends who shared a similar childhood in terms of abundant time spent out of doors. Rod grew up in Lapeer, in the Thumb area of Michigan, and I grew up farther south in Kalamazoo, but we both resettled to the same part of northern Michigan. Many of the photographs and experiences recorded in this book happened near where we now live. The story related to each photograph is conveyed through Rod's eyes, but in many respects the images correspond to my memory of comparable events and settings. Even when not working together, our different professions still involve studying the natural world we both came to love so long ago.

Rod photographs nature in its own setting, with no manipulation of creatures or environment. In the case of animals, Rod attempts to portray the subject as honestly as possible, without the use of free food or other inducements. Many of the subjects in this book have subtle imperfections, proof that they were photographed in the wild rather than under contrived conditions. All of Rod's photographs are thought-provoking, taking the viewer on a visual journey through a place rather than providing immediate emotional impact. This way of doing things is important to Rod, because the subject matter and his life are so closely intertwined. The images in this book are his way of sharing a deep enthusiasm and appreciation for nature.

For myself, I think constantly about the shortness of our time here on earth. Each passing sunset is one less that a person will see in his or her lifetime. I worry for my children, because the future is uncertain, and some of the special places shown in this book may be gone by the time they reach adulthood. Frogs, for example, are already declining worldwide, for reasons linked to increased pollution and habitat destruction, and there are far fewer numbers now than when I roamed the countryside as a child only 20 years ago. A day may come when there are no more peepers or wood frogs to announce the arrival of spring in the flooded woodlands of Michigan, and a major part of the place will disappear if this happens. A pond is not much in and of itself, but add twilight, ducks and frogs, a great blue heron standing still, a mink circling the shore, and red-winged blackbirds singing from the shrubbery or swaying in the reeds, and then you have something special. These things are the pond. Take away any one of these parts and the whole becomes diminished. Take away several parts and the setting becomes only a memory. As generations pass the memory fades, until nothing remains.

Drake mallard, on a small vernal pond, Michigan

A wild, natural beauty remains inherent in many indigenous creatures that have become routine fixtures of city and suburban settings. Often taken for granted, these animals have transcended the environmental changes brought about by centuries of intensive agriculture and urbanization. The mallard, Canada goose, American robin and herring gull are all examples of how a few types thrive in the wake of extreme habitat disruption or modification, while numerous others that are less adaptable disappear. Some animals that co-exist reasonably well with people are merely overlooked during everyday life, because of protective camouflage coloration or a nocturnal or obscure lifestyle.

Mallards are a joyful harbinger of spring in northern Michigan where Rod and his wife Marlene currently make their home. Rod vividly recalls taking long walks as a child through rural woods and fields soon after the snow had melted away, transforming normally dry depressions into ephemeral ponds full of aquatic life. Each pond seemed to contain one or more pairs of mallards in fresh plumage, newly returned from wintering grounds farther south. This drake occurred on the same sort of spring pond but 20 years later, when Rod was equipped with a camera instead of binoculars. The alert look in the bird's eye proves that it is still a wild and wary creature, constantly scanning the ragged borders of the pond for signs of danger.

CAMERA
The New Canon F1

LENS
Canon 500mm f/4.5L

FILM
Professional Fujichrome 100

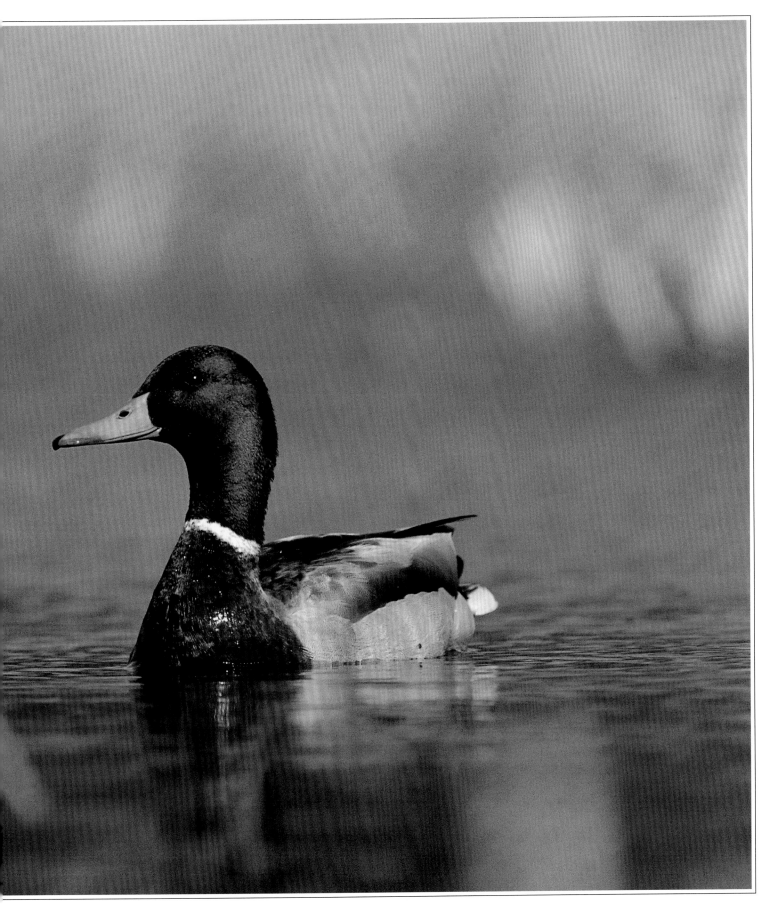

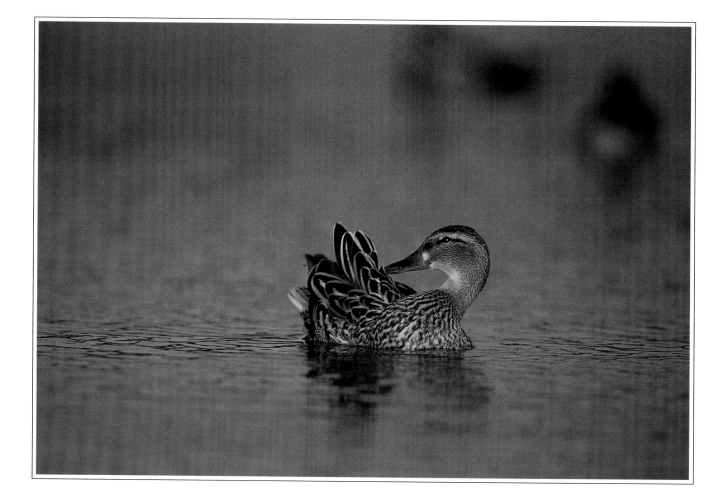

Hen mallard, on a small vernal pond, Michigan

Wild mallards are most visible in early spring during the courtship period, but are never easily approached. Rod got close to this hen by concealing himself as a small hummock on the shore of the same pond frequented by the drake on the previous page. To make the hummock, Rod first gathered up bundles of dry stalks and other debris while the sun was still high overhead and no ducks were in sight. He then crawled inside a camouflage bag resembling a giant pillow case, and reached around and tossed the stockpiled materials over the bag until only the end of the long telephoto lens protruded from the hiding place. The camera was mounted on a Gitzo tripod set flush with the ground. Rod stayed in this prone position for up to five hours at a stretch, sometimes taking a nap early on while waiting for daylight to turn golden as afternoon stretched into evening. On more than one occasion he awoke to the sounds of soft quacks and grunts made by contented ducks feeding nearby. The ducks remained for only a short time in the evening, taking off at dusk for more protected roosting areas.

CAMERA
Nikon F4

LENS
Nikon 500mm f/4

FILM
Professional Fujichrome 100

Canada goose, Thunder Bay River, Michigan

The eager honking of Canada geese is the most welcome sound of spring in northern latitudes, confirming that the season of long frigid nights is indeed over and that soon there will be great rebirth. Flights of geese begin to arrive as soon as the ice goes out, and increase steadily in number until at last one trails another all day long in a mad rush towards the Arctic tundra and intervening boreal lakes and rivers. An appreciation of Canada geese is a matter of place and perspective, however. In other parts of the country the birds are often considered to be pests, accused of destroying agricultural crops and fouling waterfront lawns and beaches. Rod was able to canoe close to this wild gander only because it was standing sentry over a nearby nest on top of a muskrat house, where its mate continued to sit tight throughout the encounter.

CAMERA
The Old Canon F1

LENS
Canon 500mm f/4.5L

FILM
Kodachrome 64

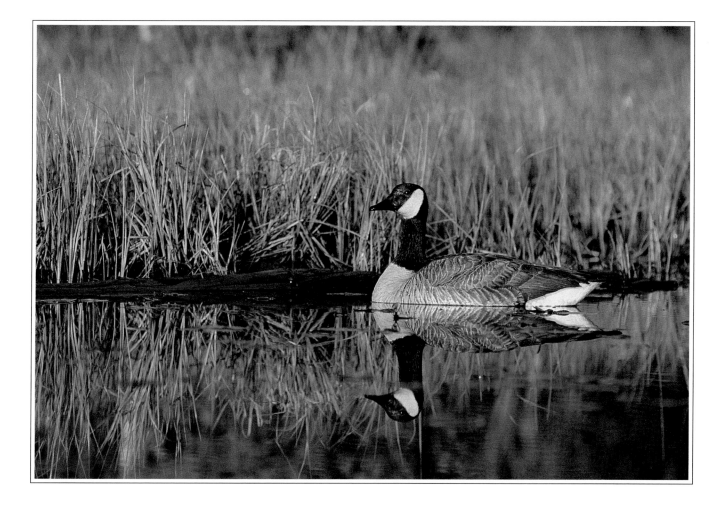

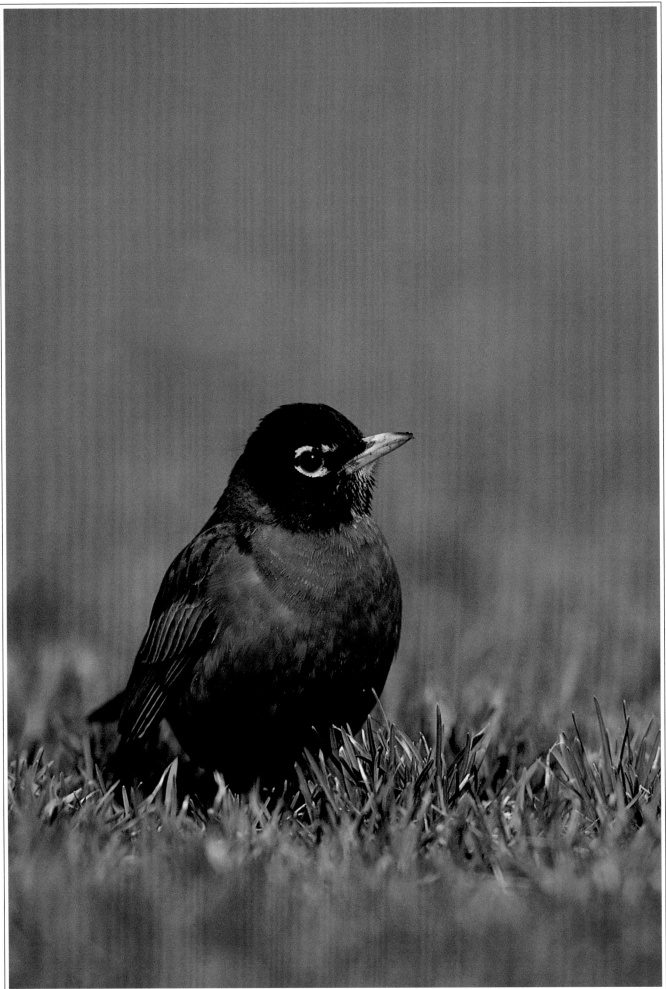

American robin on a lawn, and in a forest, Michigan

The robin is one of the most ubiquitous and well-known birds in North America, associated with lawns and yards to a degree unsurpassed by any other species. Robins are frequently seen with an eye and ear cocked toward the ground, just before reaching down and yanking up a wriggling earthworm. During the breeding season robins begin singing when the morning is but a few minutes old, and often are the last to be heard as the dark of night descends. Rod became interested in photographing robins one spring and spent several days stalking them in a small city park near his home. Despite being accustomed to people, the birds resented his approach, and it took a number of attempts to arrive at this photograph of a robin on a lawn, taken from about 15 feet away.

Robins in natural habitats are warier than those in backyards and city parks. The image below evolved unexpectedly on a cold April day, when the clouds above sometimes spitted snow and sometimes parted. The bird migration was underway, and there were dozens of robins lingering everywhere, forced down by the poor weather. Rod was walking briskly down a fencerow at the edge of a small clearing, trying to head off a flock of hen turkeys trailed by two big toms in full breeding splendor. Suddenly he saw this robin up ahead with its back turned toward him, vigorously kicking up leaf litter in search of insects. Rod dropped to his knees, crawled to within about 15 feet of the bird, focused the camera and whistled softly. The robin stopped kicking and looked back for just a brief instant before flying away.

CAMERA
Nikon F4

LENS
Nikon 500mm f/4

FILM
Professional Fujichrome 100

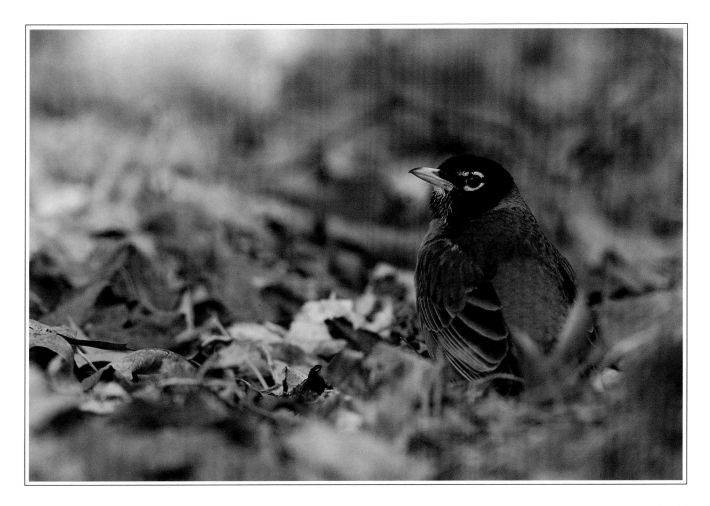

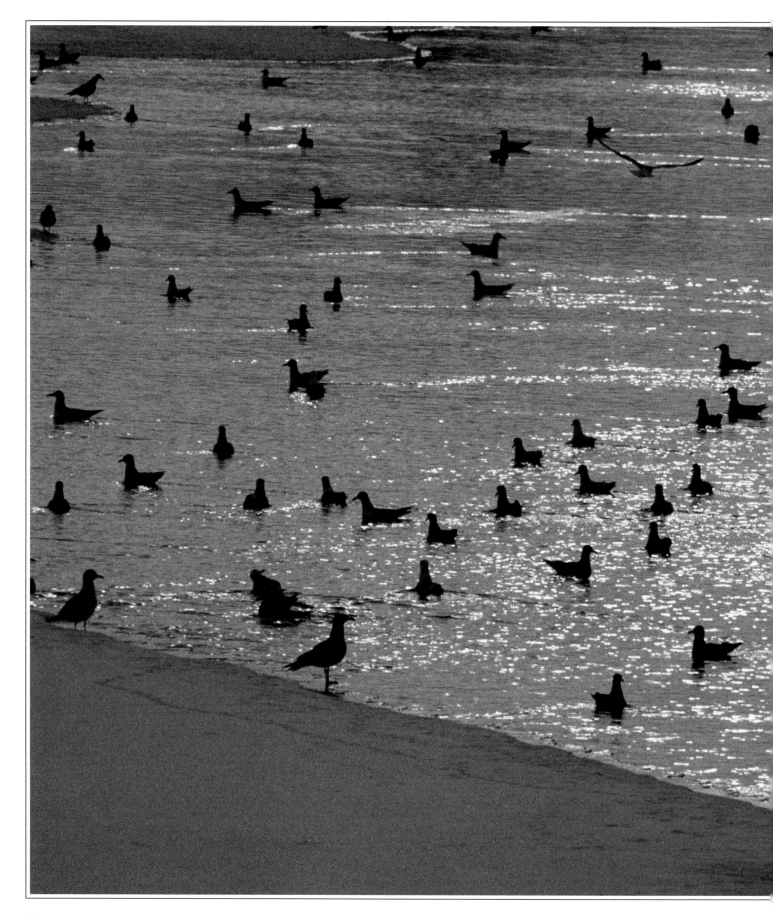

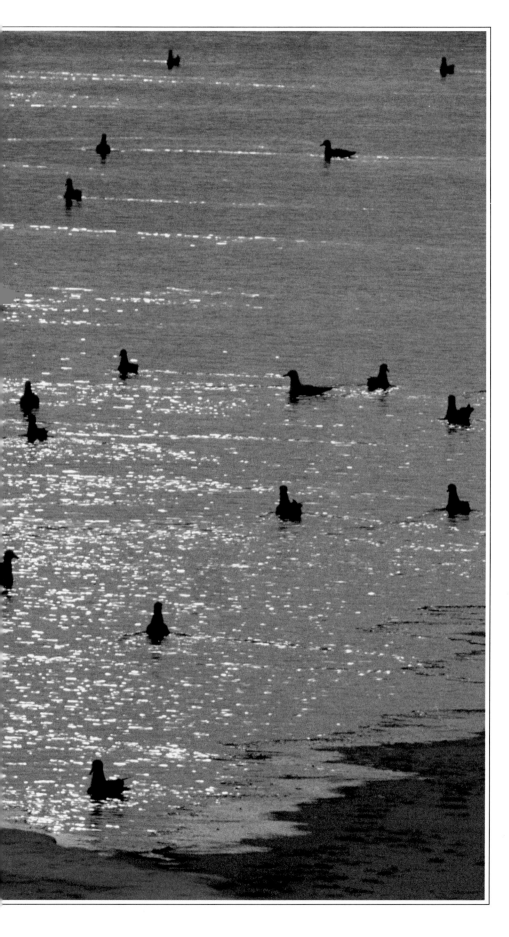

Herring gulls at winter twilight, Saginaw River, Michigan

The herring gull ranks high among animals that have seized opportunities afforded by urbanization and pollution. Herring gulls are able to metabolize and detoxify foods heavily contaminated with poisonous chemicals, making them ideally suited to forage in landfills and polluted estuaries and bays, as well as less-disturbed stretches of shoreline and agricultural fields. The birds remain dispersed throughout much of the year, but congregate in great numbers during fall and winter along major river systems when lakes farther northward become icebound. The gulls are drawn to the Saginaw River by an abundance of gizzard shad prey. The population of gulls becomes increasingly concentrated around the river mouth as stretches upstream glaze over with ice, until at last up to 20,000 or more may accumulate inside the limits of Bay City by early to mid January. A few glaucous, Iceland and Thayer's gulls are also present in this scene, which was taken late in the afternoon from a bridge overlooking one of the few remaining patches of open water.

CAMERA
Nikon F4

LENS
Nikon 500mm f/4

FILM
Professional Kodachrome 200

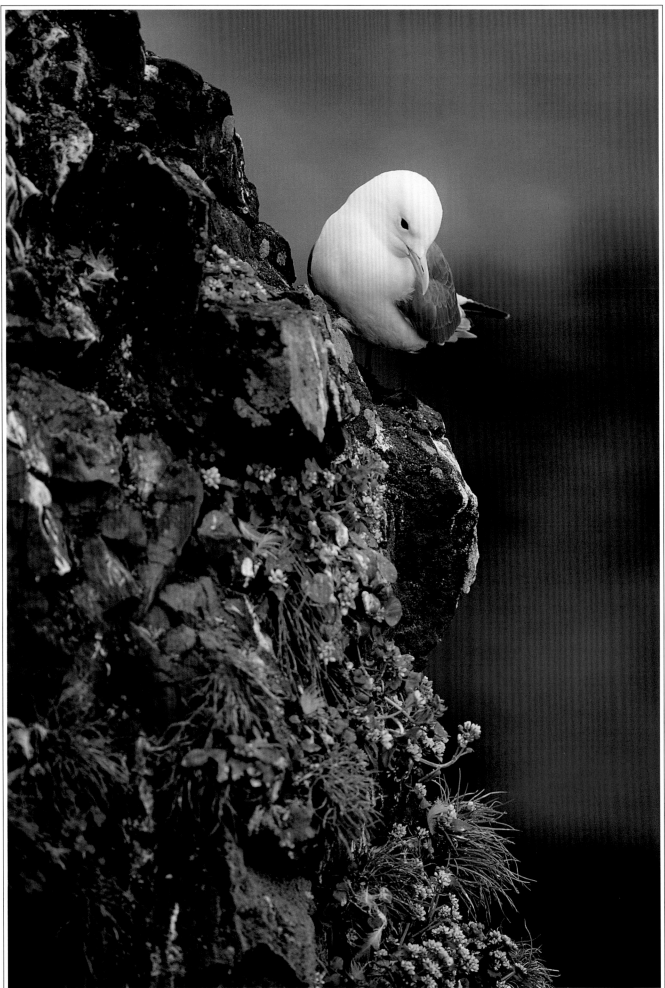

Black-legged kittiwake, Pribilof Islands, Alaska

The generic term "seagull" is frequently and carelessly applied to any one of about 30 species of skuas, jaegers, gulls and kittiwakes that spend time along the oceans and coastlines of North America. Most people do not realize that such great diversity exists among this type of bird, and that each species has its own unique life history. The black-legged kittiwake, for example, is a pelagic seabird that nests in colonies on narrow rock ledges, sometimes high above the swelling sea. This photograph was made on St. George Island of the Pribilof Archipelago, located in the Bering Sea. Rod and other nature photographers attempt to visit the island in early July, to observe and photograph some of the 12 different species of seabird that nest there.

CAMERA
Nikon F4

LENS
Nikon 500mm f/4

FILM
Fujichrome Velvia pushed one stop

Barred owl in late winter, Michigan

This barred owl, perched at the side of a well-traveled road, could be easily overlooked. It is not uncommon for barred owls to hunt during daylight hours in late winter, when normal food supplies have been seriously depleted. The photographic image breaks with traditional guidelines of composition because the subject is looking out of the frame. It is effective, however, because of how the owl is portrayed in relation to its surroundings. The two aspen trunks and intervening arched branches subtly direct the viewer's attention to the cryptically patterned bird.

CAMERA
Nikon F4

LENS
Nikon 500mm f/4

FILM
Professional Kodachrome 200

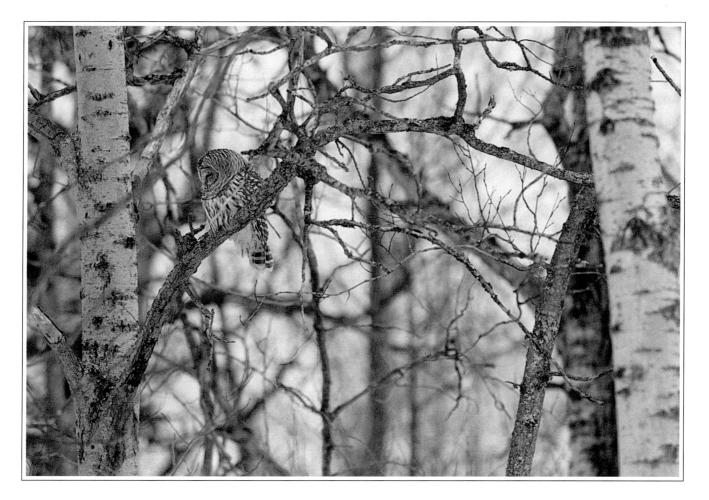

Desert cottontail, Badlands National Park, South Dakota

A buff-colored coat tinged with black and silver gives this cottontail a strong sense of security amid the dry prairie grasses surrounding its burrow entrance. Feeding and other activities are usually confined to the nighttime hours, but this one stayed out past dawn on a bright, overcast morning. It is alert but remains frozen in an effort to foil potential predators, which zero in on prey movement. Rod loves rabbits and hares, and he spends many hours in the field photographing them. He often wonders how many he has passed by unknowingly over the years. Humans have a tendency to focus on the big picture, and thereby overlook many of the fine details. It takes great concentration and the right mindset for us to differentiate the outline of an ideally camouflaged animal in its natural environment.

CAMERA
Nikon F4

LENS
Nikon 300mm f/4

FILM
Fujichrome Velvia pushed one stop

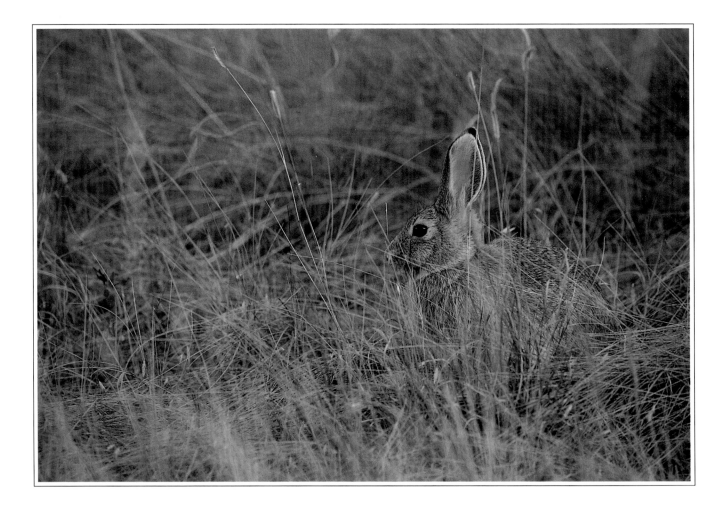

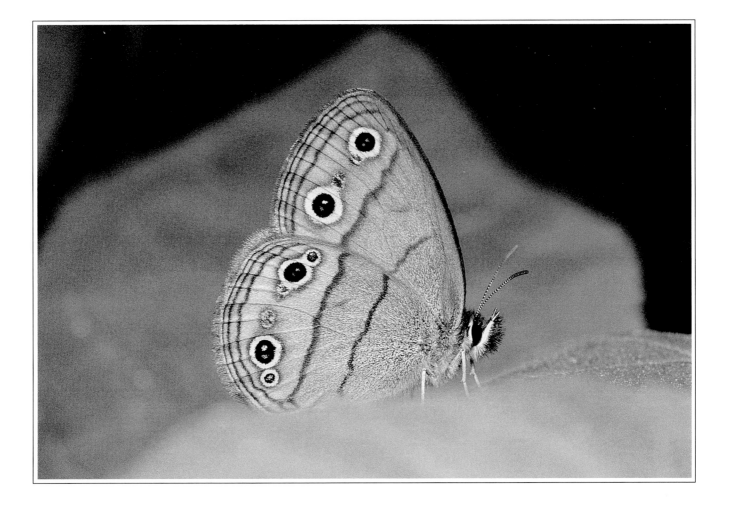

Little wood satyr, Michigan

Small inconspicuous creatures can be quite handsome. The iridescent eye-spots and rich brown tones on the underside of this spring butterfly are not visible in flight, and thus it could be mistaken at first glance for a drab moth. The beauty only becomes apparent upon closer inspection, when the butterfly is sitting still. Its head and delicate antennae are also ornately patterned. This little wood satyr came to rest on the blade of a large-leaved aster in Rod's backyard. Rod used a small electronic flash, contained on a hand held camera unit, to illuminate the subject.

CAMERA
The Old Canon F1

LENS
Canon 100mm f/4 Macro

FILM
Kodachrome 25

View from White Mountains facing west towards the Sierra Nevada Range, California

Uncomplicated scenes and places tend to emerge from the raw interactions of earth, water, wind and sky. The results can be transitory, such as the build-up of ice along a shoreline, or as permanent as cracks in a canyon wall. The landscape of arid regions is especially rich in basic elements, because a reduction or absence of vegetation helps to accentuate contours of the earth. But similar places are also found tucked away amid the verdant clutter of temperate regions, for example where a small pool dries up leaving a mud-cracked bottom. The arrival of winter likewise brings great simplification, as snow obscures all but the most prominent features of the landscape.

Still photography is an excellent medium for isolating the basic elements of nature. This composition involves the juxtaposition of overlapping ridgelines, a technique often applied to scenes of sunsets. Here it is late afternoon and the light is diffuse, lending a peaceful aura to sagebrush covered hills that were scorched by the midday sun a few hours earlier. The base of the Sierra Nevada mountain range is barely visible through the hazy background, leading up to snow-capped peaks that were purposely cropped out of the photograph.

CAMERA
Nikon F4

LENS
Vivitar 100mm f/2.8 Macro

FILM
Fujichrome Velvia

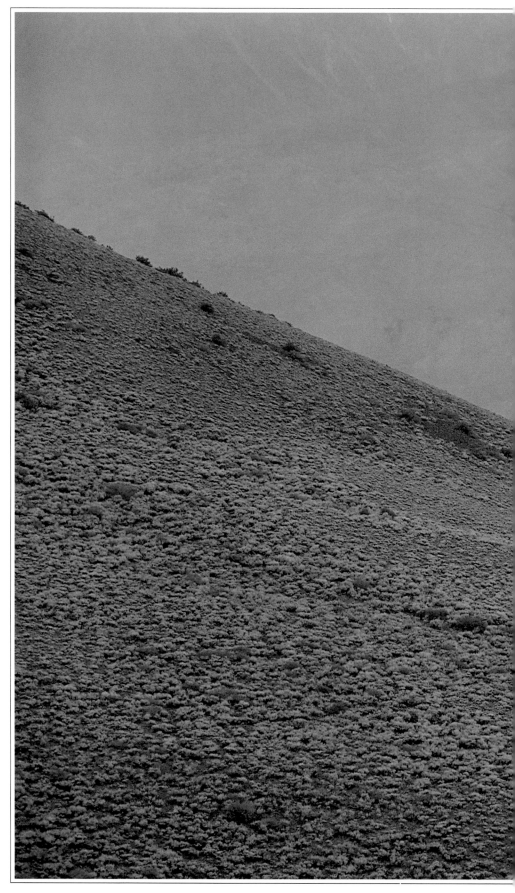

2: BASIC ELEMENTS

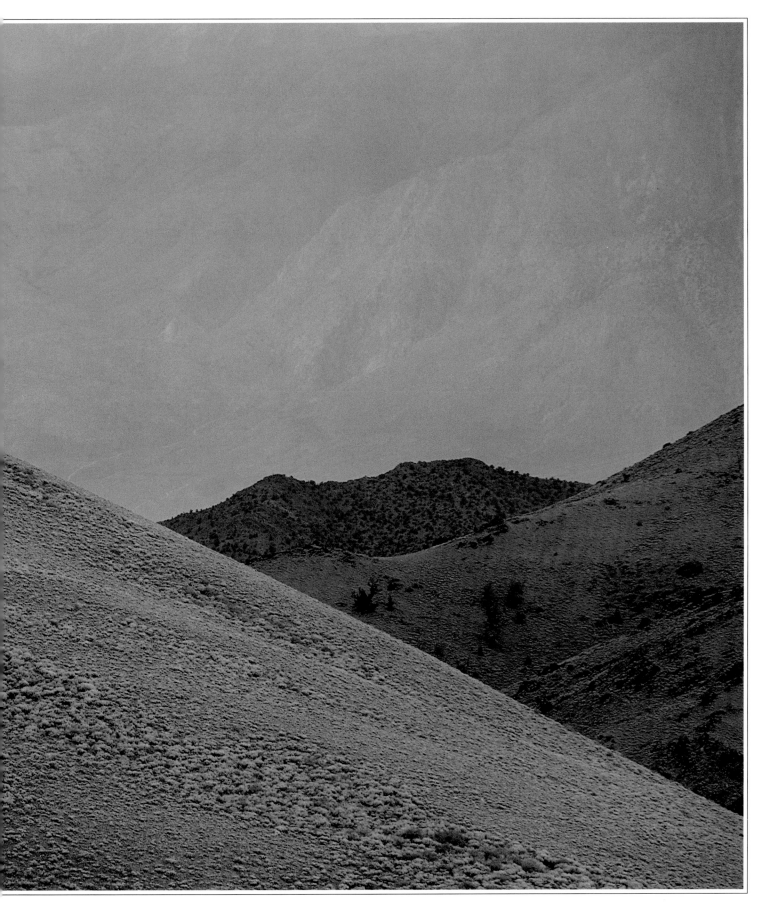

Cracked mud along Lake Huron, Michigan

Composing an image of cracked mud is a challenge better suited to photography than to painting or sculpture. The abruptly twisted lines within this frame lead imperceptibly to the well-defined circular area in the bottom right hand corner, bringing an ultimate sense of order to something that at first glance may appear disconnected. This mudflat was a one season phenomenon, formed when the level of Lake Huron dropped rapidly following a prolonged high water stage. The area is now covered with a sea of grasses.

CAMERA
Nikon F3

LENS
Canon 35mm f/2.8 Tilt/Shift
converted to Nikon mount

FILM
Professional Fujichrome 50

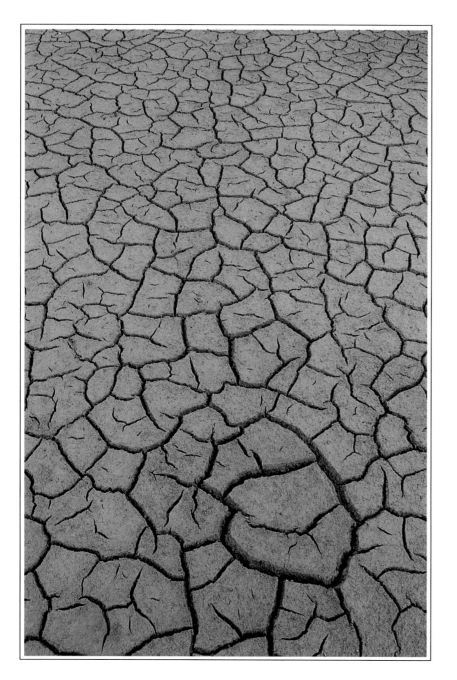

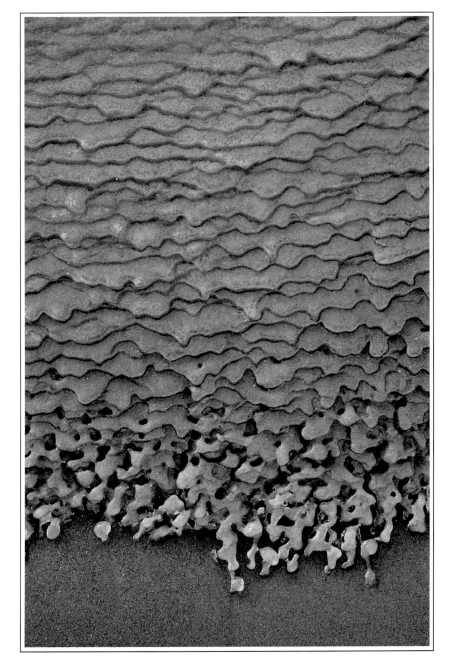

Frozen shoreline along Lake Huron, Michigan

Familiar places can appear unfamiliar and unique in different light or another season. This photograph was taken along the same stretch of Lake Huron shoreline as the cracked mud, but in early December. Rod walked the beach during a calm but cold spell after a period of rough weather, and came upon this strange conglomeration of sand and ice. It had formed overnight through the action of crashing waves, driven by stiff winds that tossed heavy spray far up on shore. The water apparently froze quickly as it drained backward, trapping and arranging the suspended sand particles into orderly, overlapping layers. Then, at some later time, the lake lapped at the edge of the formation, altering its form as seen near the bottom of the frame.

CAMERA
The Old Canon F1

LENS
Canon 100mm f/4 Macro

FILM
Kodachrome 25

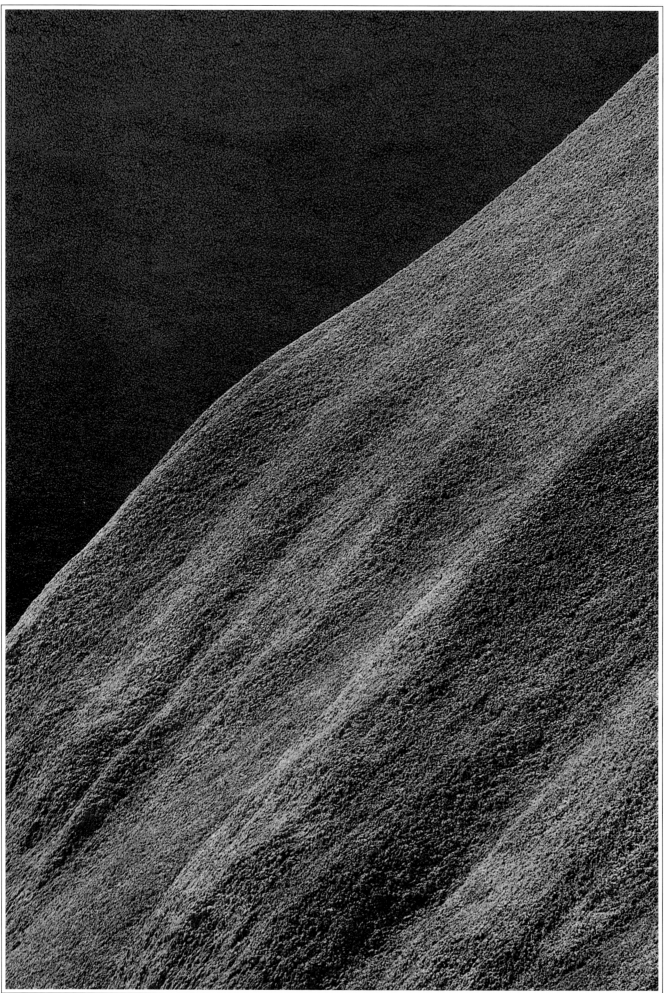

NATURE'S PLACES

Section of Yellow Mounds, Badlands National Park, South Dakota

Today life can barely gain a foothold in the crumbling slopes of the Badlands, parched by wind and sun and worn down continually by the forces of erosion. These hills are made of dust rather than rock, and the subtle hues in the foreground of this photograph are caused by sunlight reflecting off the different layers of sediment deposited in ancient times. The distance between the two slopes has been greatly compressed through the use of a long telephoto lens. The photograph was taken within a hundred feet of a popular scenic view along a well-traveled highway. Tourists who stop there are overwhelmed by the immensity of the land, and most probably would not narrow their attention to this one section of mound. Through a photographer's well-trained eye, however, these hills can be explored and isolated in new and different ways.

CAMERA
Nikon F4

LENS
Nikon 300mm f/4

FILM
Fujichrome Velvia

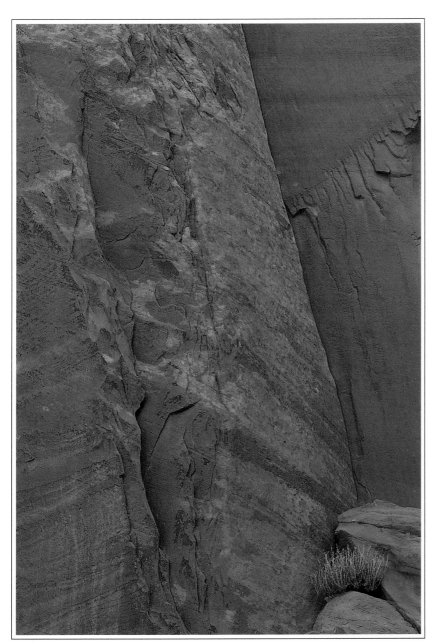

Canyon wall, Capital Reef National Park, Utah

Rod spent a week viewing rock faces from all distances and angles, before determining how to approach them in terms of photographic composition. He finally realized that something familiar was needed to anchor the frame and provide scale, because the faces were so visually overwhelming. Here he used a short telephoto lens to isolate a lone sagebrush against a section of canyon wall.

CAMERA
Canon EOS 10S

LENS
Canon EOS 90mm f/2.8 Tilt/Shift

FILM
Fujichrome Velvia

Grand Sable Dunes, Pictured Rocks National Lakeshore, Michigan

Scenes of the American East and Midwest are sometimes difficult to simplify, because of the obtrusive presence of cities, suburbs, roads, powerlines, farms and other fixtures of settlement. Residential development has especially altered the face of coastlines, giving them a cluttered and tame appearance. This photograph, taken from the top of a dune along Lake Superior, shows one of the few stretches of pristine shoreline remaining on the Great Lakes. The lighthouse barely visible at the end of the point is the only article produced by human hands. The simple composition is formed by an unbroken line, tracing the interface of land with water around to the end of the point, and then continuing back along the skyline. The line separates two differently textured forms, one a peninsula of land, appearing scaly because of a thin skin of vegetation, the other a translucent blend of water and sky. A wide-angle lens was used to emphasize the distance between foreground and background.

CAMERA
The Old Canon F1

LENS
Canon 24mm f/2.8

FILM
Professional Fujichrome 50

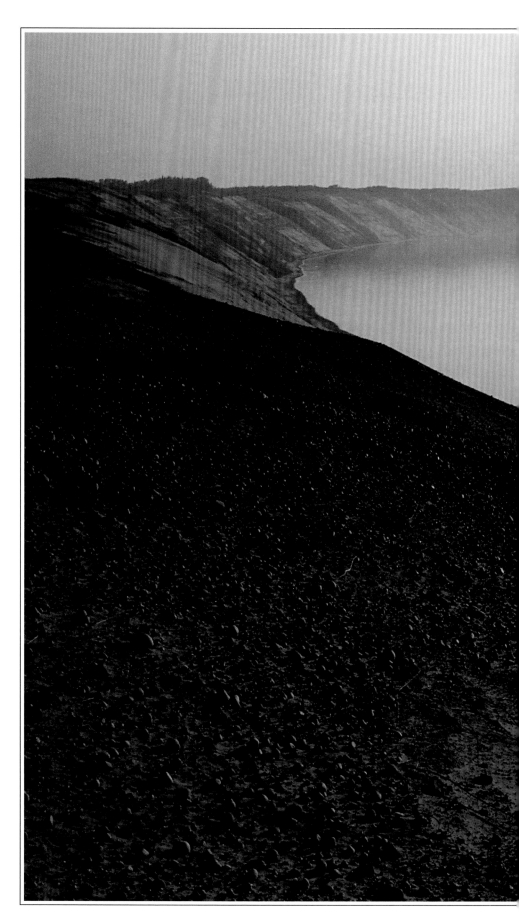

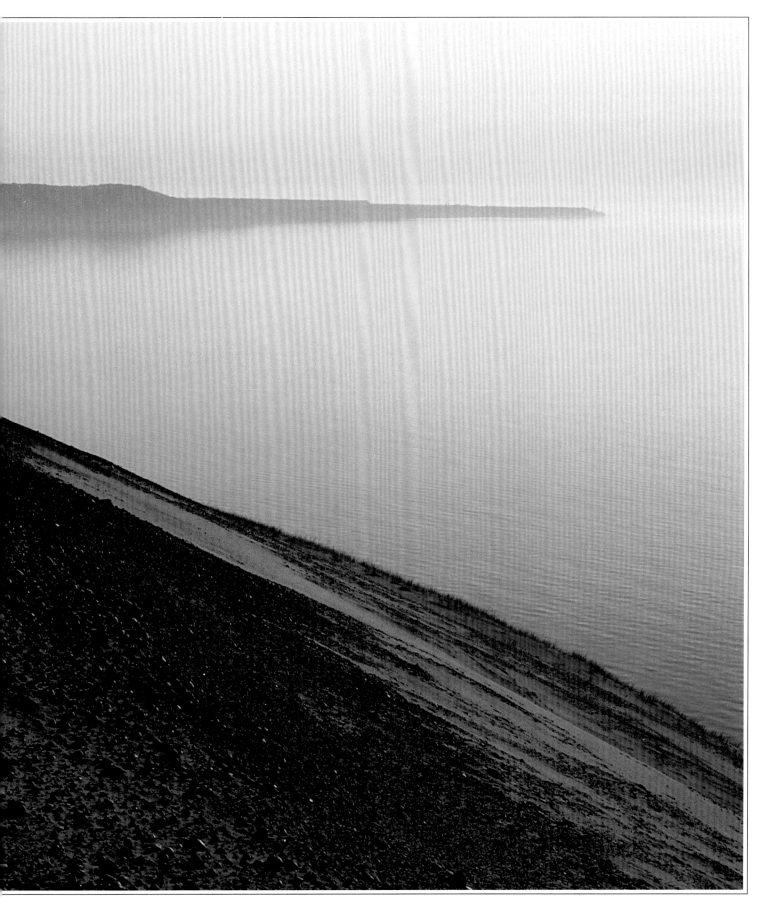

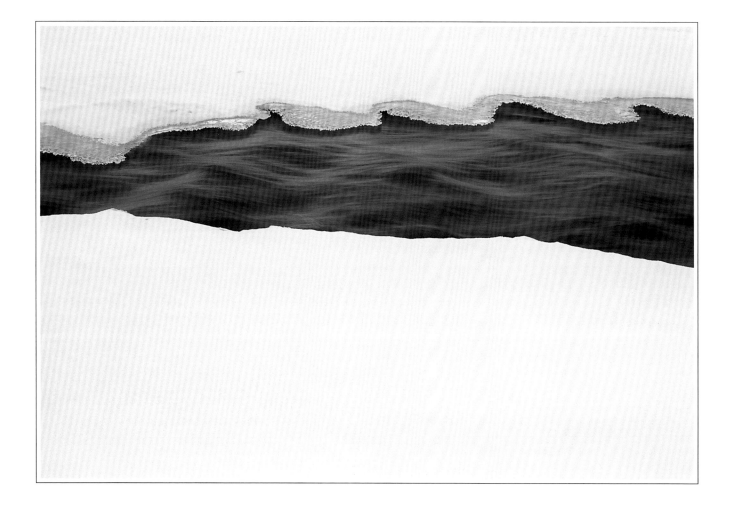

Soda Butte Creek, Yellowstone National Park, Wyoming

Rod studied the constantly changing formation and dissolution of new ice along the banks of this swift creek whenever he stopped nearby to watch bighorn sheep. The creek parallels a paved, snowplowed road. One morning, after a light snow, the creek became a more interesting subject than the sheep, and he spent three hours photographing it. Reflections of pale sky caused the surface of the water to appear milky at first. Rod was able to eliminate the distracting reflections by using a polarizing filter, thus darkening the water and separating it from the snow-covered bank in the foreground.

CAMERA
Canon EOS 10S

LENS
Canon EOS 45mm f/2.8 Tilt/Shift

FILM
Fujichrome Velvia

Lichen on boulder, Neys Provincial Park, Ontario

Life on a weathered rock, where nutrients and moisture are gleaned from the air, is among the most basic of existences. This dime-sized colony and others like it occur on granite boulders as big as a car along the shore of Lake Superior. Lichens are the result of an intimate relationship between certain kinds of algae, which convert sunlight into food through the process of photosynthesis, and fungi that grow around and envelop the algal cells. The relationship was long thought to be symbiotic, with the algal partner trading food and nutrients in exchange for protection from drying out. But recent evidence indicates that the fungus, which cannot photosynthesize, actually may be a benign parasite upon the alga. The lichen's ability to cease photosynthesis and dry out quickly without harming itself is apparently key to survival in harsh environments, where it becomes dormant in order to endure periods of extreme heat or cold.

CAMERA
Nikon F3

LENS
Vivitar 100mm f/2.8 Macro

FILM
Professional Fujichrome 100

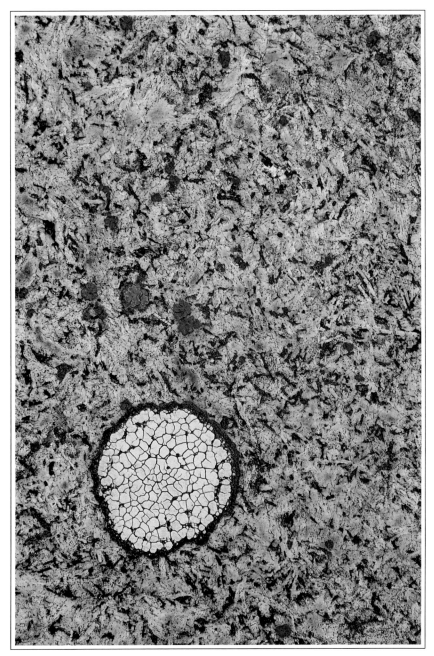

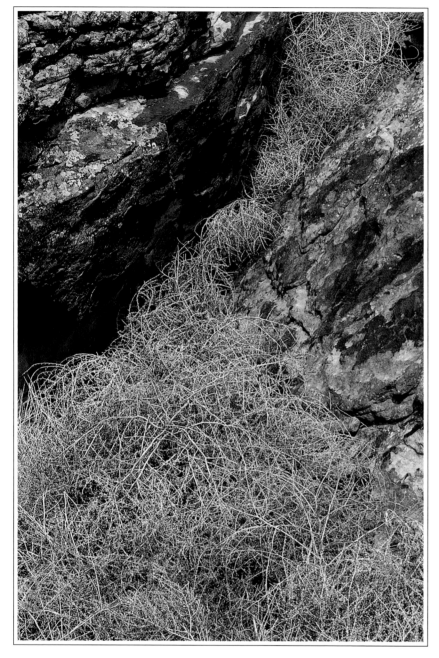

Tumbleweeds and boulders, Rabbit Valley, Colorado

Effective photography of basic elements requires the study of subtle shapes and rhythms, usually drawn from faint contrasts between earth-tone colors that do not immediately command attention. In many senses, these are photographs of nothing in particular. Here Rod has concentrated on a tumbleweed repository at the base of a canyon wall. Wind has pushed some of the tumbleweeds up into a crack, giving distinct visual form to the chaos of intertwined bleached branches. It takes considerable training and practice to see this sort of image and be able to isolate it from the face of a larger, less-interesting background.

CAMERA
Canon EOS 10S

LENS
Canon EOS 90mm f/2.8 Tilt/Shift

FILM
Fujichrome Velvia

Claret cup cactus, Colorado National Monument, Colorado

Simplicity in nature is a matter of perspective. From a distance these claret cup cacti blend into a background of sun-baked dust strewn with fractured chunks of sandstone and shale, overgrown in places with clumps of sage and rabbitbrush, pinyon pine and juniper. When viewed close-up, the cacti are reduced to fleshy bodies coated with long, curved spines that seem to rotate like cogwheels. This appearance of simplicity is complicated just once each year when the cacti burst into flower, adding a short-lived but breathtaking splash of color to the scene.

CAMERA
Canon EOS 10S

LENS
Canon EOS 90mm f/2.8 Tilt/Shift
with a Nikon #5T close-up lens

FILM
Fujichrome Velvia

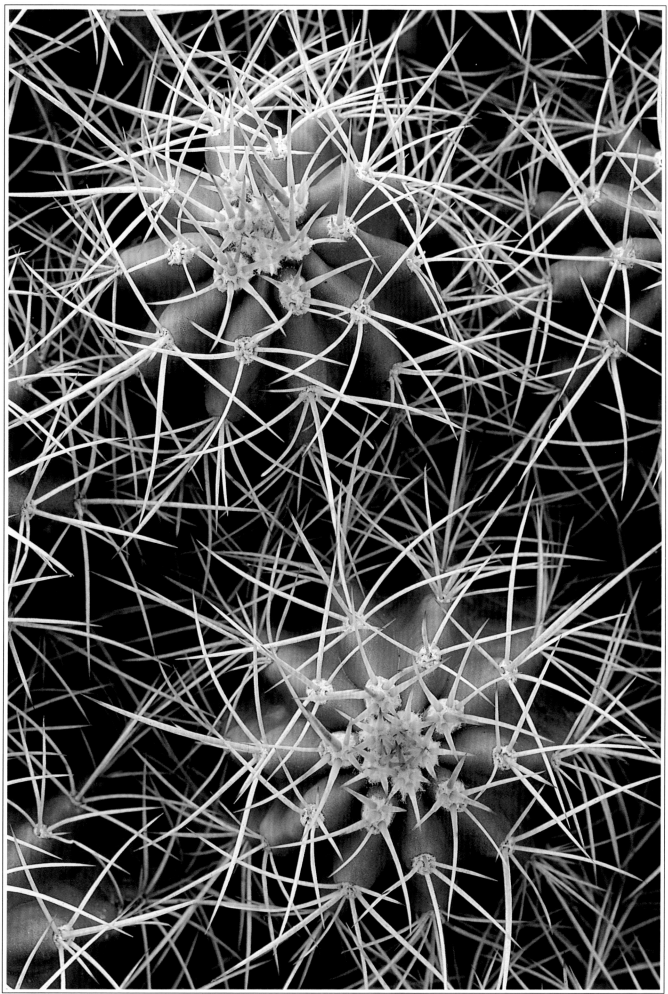

*Red maple tree in autumn,
Michigan*

Spring arrives with a flourish in desert country, primed by rainfall that is notably absent for the remainder of the year. In comparison, spring progresses in a more restrained manner in temperate regions, where the yellows and greens of new growth soften the land in increments. Summer follows with sultry days punctuated by an abundance of bird song, leading into the relative calm of August and early September, when most birds are quietly wandering in family groups, preparing for the long trek southward or the return of winter. The growing season ends in temperate regions much like it begins in desert country, with a profuse but short-lived burst of color.

Photographic opportunities like those afforded by this red maple are present for only a few days each year. Rod spotted the tree from a long way off, growing on the edge of a dry clearing where it had been able to spread outward. A bright but overcast sky with no wind presents ideal conditions for photographing this type of subject, helping to reduce contrasts and allowing the retention of maximum color and detail.

CAMERA
The Old Canon F1

LENS
Canon 100mm f/4 Macro

FILM
Kodachrome 25

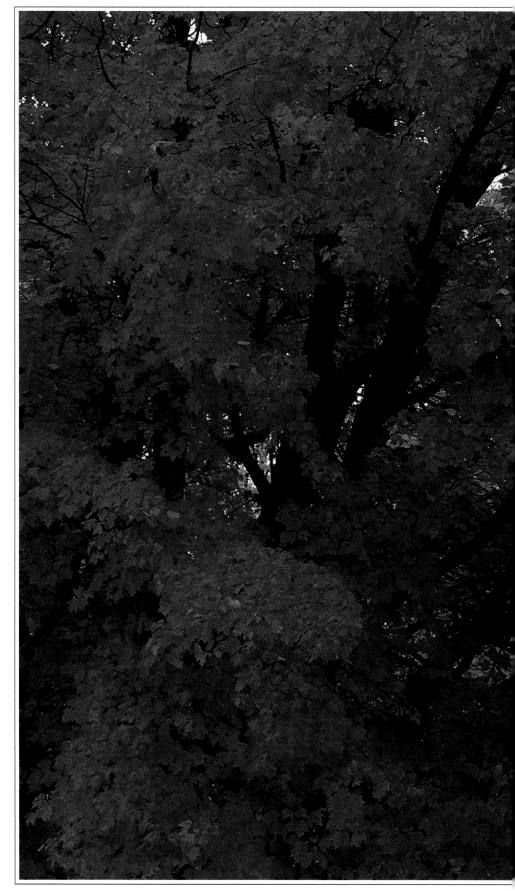

3: RICHNESS

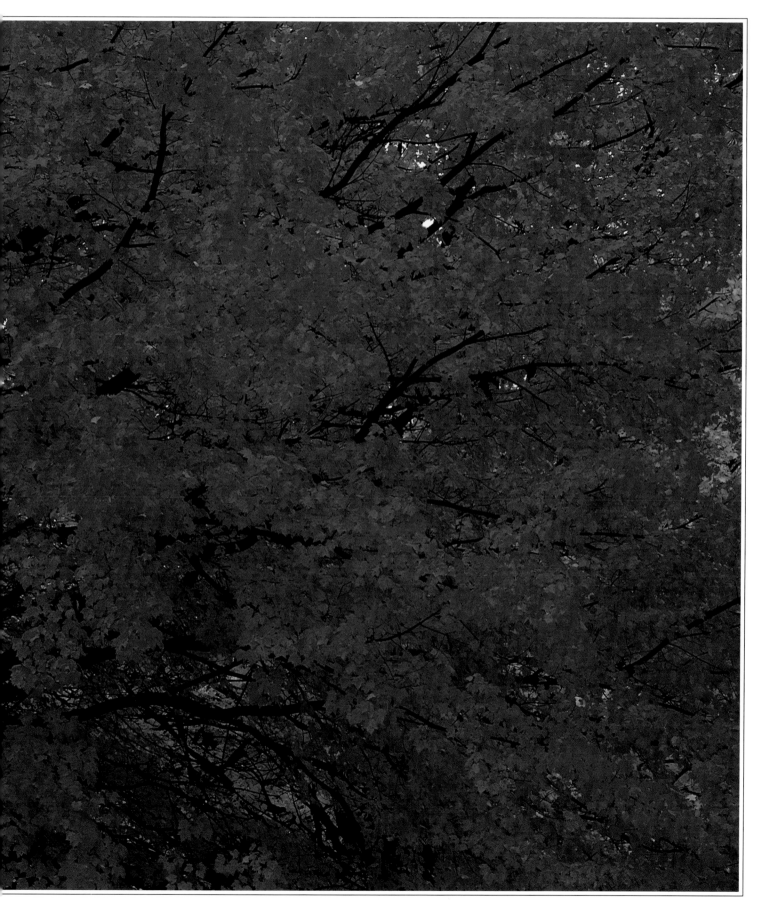

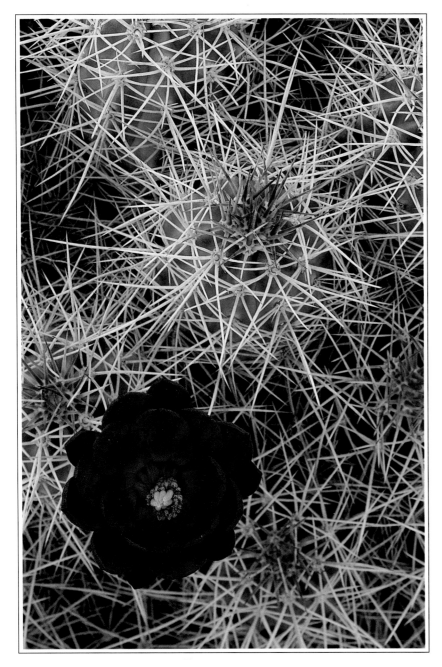

Claret cup cactus, Rabbit Valley, Colorado

Red is the most eye-catching color in nature, often exaggerated by surroundings that are painted various shades of brown and green. For example, it is difficult to envision claret cup cacti in terms of basic elements, as done several pages ago, when a striking blossom like this is present and commands attention. The biggest problem with photographing these cacti when in flower is deciding where to begin. Some clusters may be dotted with 10 or more blossoms at one time, and there is strong temptation to stop at the first group encountered and set up the camera. Rod tries to remain calm when coming upon such an event, and he takes an initial walk through the area to look for the freshest blossoms, unblemished by wind or insects. His goal is to find images that will best convey the beauty of nature.

CAMERA
Canon EOS 10S

LENS
Canon EOS 90mm f/2.8 Tilt/Shift with a Nikon #5T close-up lens

FILM
Fujichrome Velvia

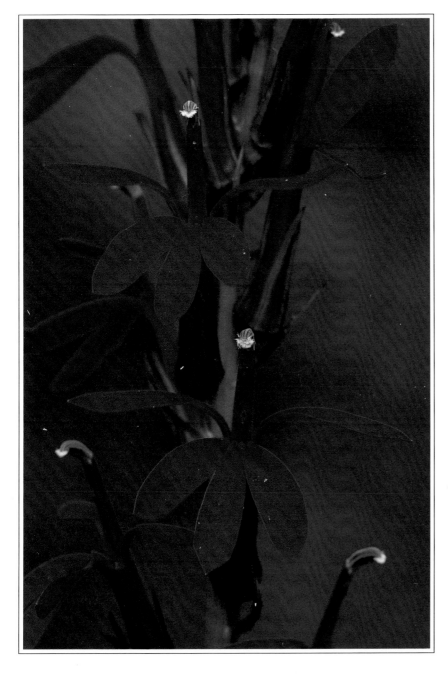

Cardinal flower, Michigan

Cardinal flower is a characteristic inhabitant of rich, wooded floodplains. It flowers in mid-summer when the forest floor is otherwise far from photogenic, cast into varying shades of darkness by a towering, unbroken canopy. The miraculous color and delicate form of the flower compel Rod to seek it year after year, despite often facing a multitude of mosquitos, 90+ degree temperatures and nearly 100 percent relative humidity. This photograph came about on a hot day when Rod was exploring an old river oxbow. He came upon a nice patch of cardinal flower just as the warm breeze that had been blowing all day began to subside. There was thunder in the distance, and the air took on a sudden coolness. Rod ran quickly back to his truck and returned with camera gear just as the first few drops began falling. A half dozen frames later the downpour erupted, pelting the blossoms and forcing Rod to seek shelter.

CAMERA
The Old Canon F1

LENS
Canon 200mm f/4 Macro

FILM
Professional Fujichrome 100

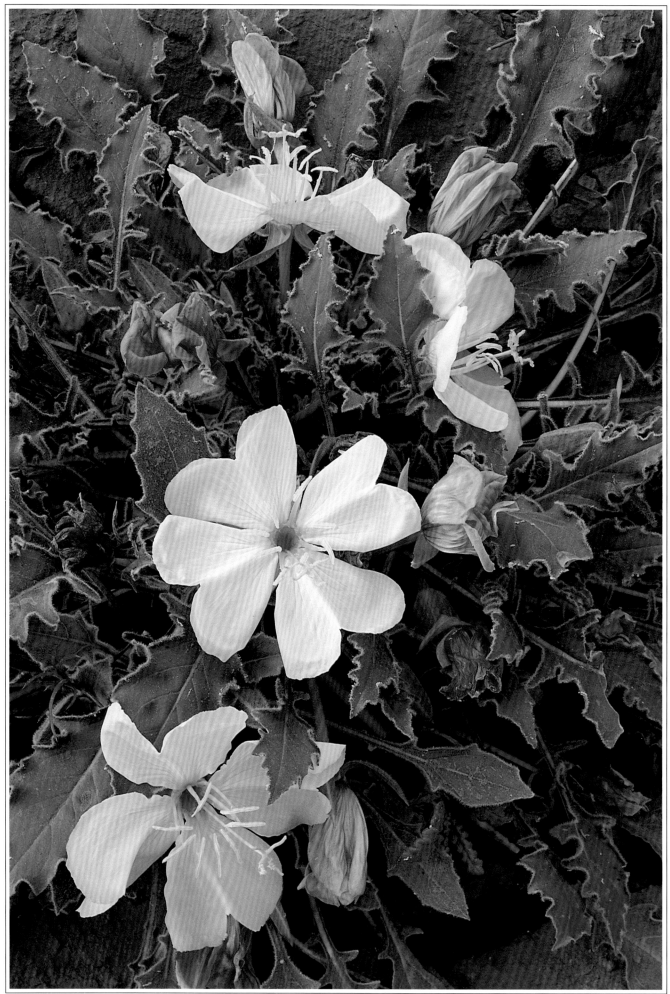

Tufted evening primrose, Capital Reef National Park, Utah

Primroses are adapted to eke out an existence in some of the poorest rock-strewn soils. The plants explode into flower with the arrival of spring rains in the plateau country of the American Southwest. Each delicate blossom lasts one night or at most two, quickly collapsing and taking on a pinkish or reddish hue as documented in these two photographs. A few fresh blossoms unfold late every evening during peak flowering times, and remain open until the following morning, when harsh sunlight forces them to close. The blossoms stay open for a longer period on overcast days.

CAMERA
Canon EOS 10S

LENS
Canon EOS 90mm f/2.8 Tilt/Shift

FILM
Fujichrome Velvia

*Yellow evening primrose,
Capital Reef National Park, Utah*

The fresh yellow blossoms on this species of primrose are the size of saucers, a singular sight when set against a background of smooth brown sandstone and reddish soil. Rod begins a morning session of photographing primroses by concentrating on individuals that grow in the open. When the sun begins to climb high in the sky, he switches to the shaded realms of canyons or outcroppings, where the light may remain even for a few more hours. After selecting a subject and setting up the camera and tripod, Rod always delays taking the photograph until there is a lull in the convection currents, or "ghost breezes", that constantly stir the vegetation. The wait may be long, but it is necessary if the resulting image is to be incredibly sharp.

CAMERA
Canon EOS 10S

LENS
Canon EOS 45mm f/2.8 Tilt/Shift

FILM
Fujichrome Velvia

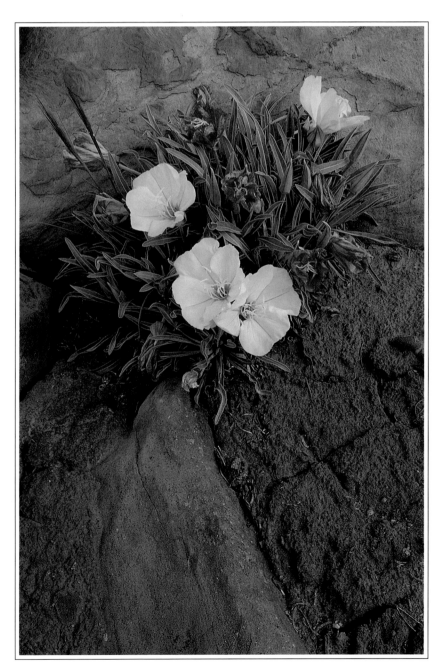

Showy lady's-slipper, Michigan

Showy lady's-slipper is another flower that Rod seeks year after year. He finds it amazing that a blossom can be so ornately beautiful. His annual quest for the orchid is driven by a desire to record a perfect image, an unattainable feat because both his photographic technique and knowledge of their biology are continually evolving. For Rod, part of the attraction lies in seeing how his way of photographing the orchid changes over time. For example, he originally used a 50mm lens to frame an individual blossom, but now prefers a 200mm or even 300mm lens. Longer lenses have a narrower angle of view, which simplifies the image by eliminating background distractions.

CAMERA
Nikon 8008N

LENS
Nikon 200mm F/4 Micro with a TC-14B 1.4 teleconverter

FILM
Professional Fujichrome 100

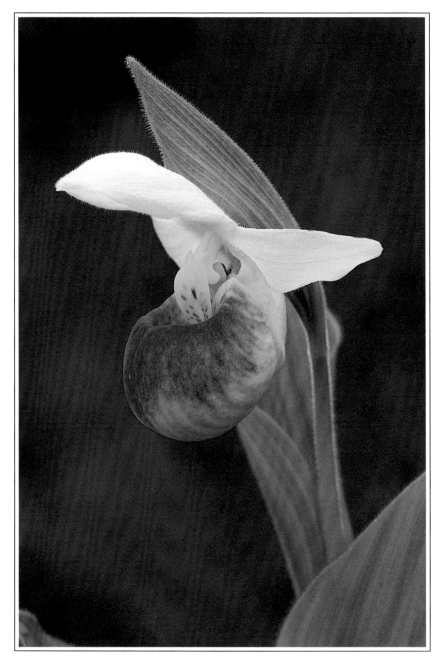

Least auklet, Pribilof Islands, Alaska

St. George Island, which encompasses about 40 square miles of wind-whipped rock covered with knee-high tundra growth, contains the largest single seabird breeding colony in the Northern Hemisphere. The colony is made up of about 2.3 million birds from 12 different species. The least auklet population alone numbers more than 250,000, which is second only to the total of nearly 1,500,000 thick-billed murres. These vast numbers of seabirds are supported by the abundant marine invertebrates and small fish found in the Bering Sea, which forms the dark background in the photograph. Least auklets are smaller than a robin, and they nest in rock crevices on talus slopes high above sea level. Rod photographed this individual as it sat about 10 feet directly below him, along the lip of a sheer cliff face nearly 200 feet high. All the while, the ground seemed to vibrate from the deafening noise made by several hundred thick-billed murres nesting on rock ledges immediately below the auklet.

CAMERA
Nikon F4

LENS
Nikon 500mm f/4

FILM
Fujichrome Velvia pushed one stop

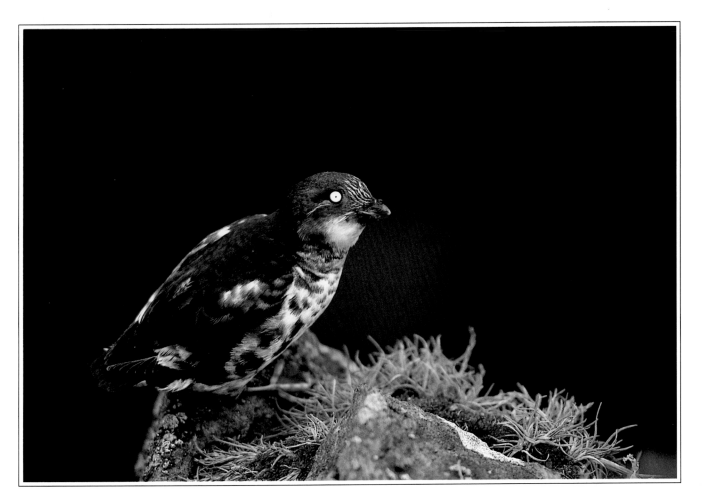

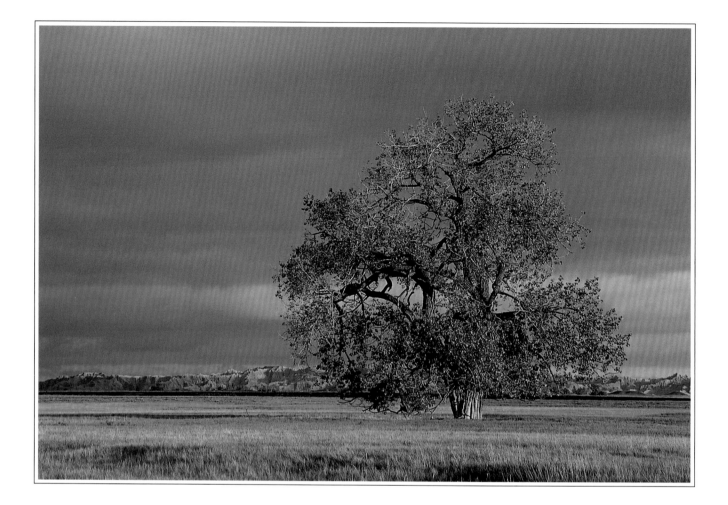

Cottonwood tree, Buffalo Gap National Grasslands,
South Dakota

This giant cottonwood seems to speak of life. Bison may have rubbed up against the tree while it was a sapling, during a time when they still freely roamed the plains. Trees like this one were a beacon for weary pioneers in covered wagons, signaling the presence of a wash or pothole that might contain valuable drinking water. Rod was drawn to the cottonwood while driving around one spring evening, and he decided it would make an excellent composition isolated against a unique morning sky. He then returned every morning for a week until conditions and timing were just right. The rising sun is touching the crests of the Badlands in the distance.

CAMERA
Nikon F4

LENS
Nikon 55mm f/2.8 Micro

FILM
Fujichrome Velvia

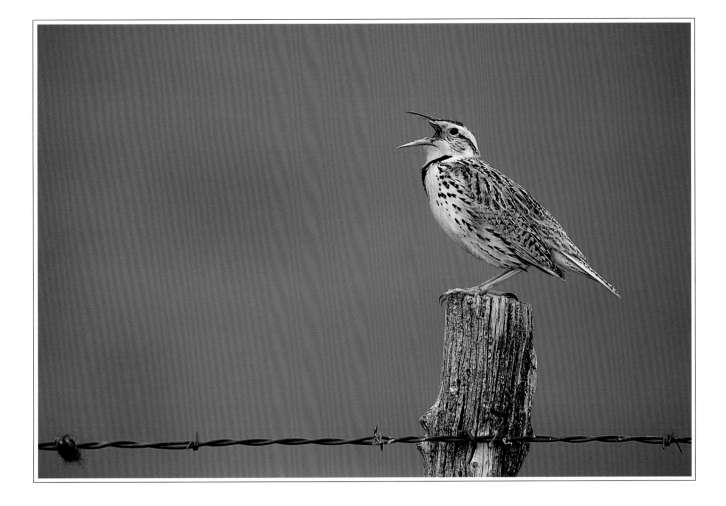

Western meadowlark on fencepost, South Dakota

More than a hundred years of homesteading and ranching have tamed the original shortgrass prairie, and old fenceposts are now as much a part of the landscape as western meadowlarks. This singing male was photographed from a vehicle using a window camera mount. A spring thunderstorm was brewing overhead, diffusing the late morning light and making colors appear deeply saturated. The nearly perfect green background, actually comprised of endless prairie grasses but blurred beyond recognition, was again created through the use of a long telephoto lens.

CAMERA
Nikon F4

LENS
Nikon 500mm f/4

FILM
Fujichrome Velvia pushed one stop

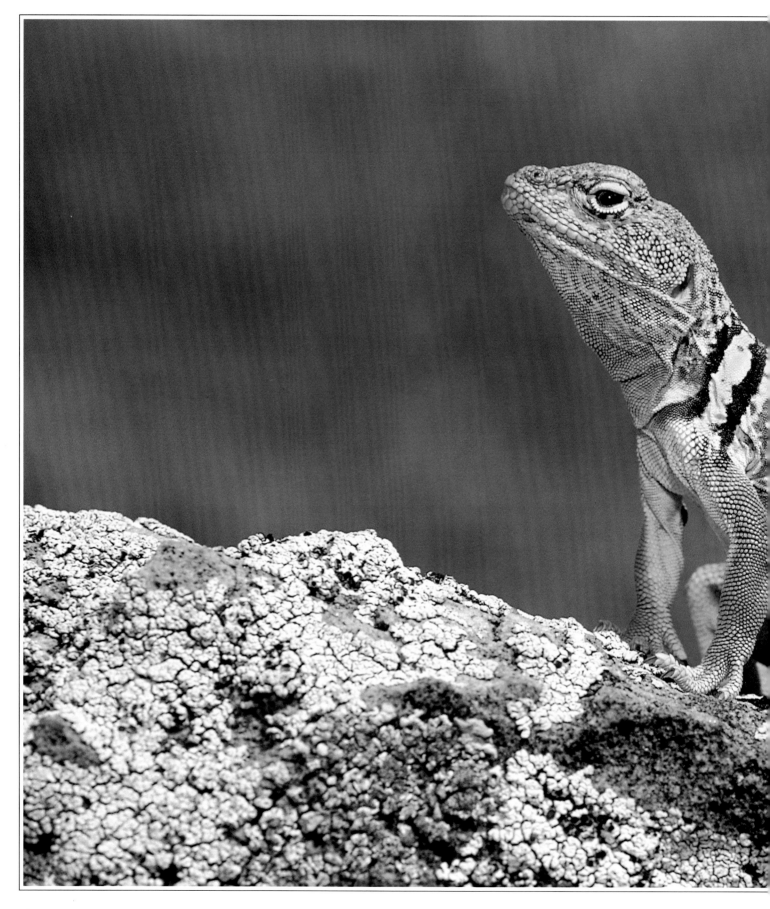

Collared lizard in wild

Meet "Lenny", a male collared lizard that Rod and Marlene met in the American Southwest. The exact location has been withheld because collared lizards are currently under attack from collectors, an increasing threat to reptile populations worldwide. Giving a name to an animal may seem anthropomorphic, but it resulted from the Plancks' becoming closely acquainted with the lizard over a span of four days. Rod spent enough time with Lenny, in a non-manipulative, non-threatening sort of way, that he eventually became a part of the lizard's environment. Lenny ate desert no-see-ums while cooling himself in Rod's shadow, spent time sunning on Rod's knee, and at one point even scaled Rod's hair to sit on his head momentarily. On the most memorable day, Rod followed Lenny through the desert for hours on a mile long loop, while Lenny searched for mates and ate bugs. Rod finds himself constantly worrying about Lenny's corner of the world. He can tolerate the idea of Lenny dying in the grasp of a golden eagle or red-tailed hawk, but not a poacher. A life in captivity, perhaps ending up as a freeze-dried specimen mounted over a fireplace mantle, is not an acceptable end to such a special creature.

CAMERA
Nikon F4

LENS
Nikon 200mm f/4 Micro

FILM
Fujichrome Velvia

Twilight, Old Woman Bay,
Lake Superior Provincial Park,
Ontario

The fine details of nature are normally obscured or blurred by a confusion of noise and movement. Birds singing, the rustling of wind in the leaves, waves crashing on rocks, steady rainshowers, torrential downpours—these events and others are beautiful yet distracting. In the midst of this everyday chaos, however, come rare times when virtually all activity grinds to a halt. The wind dies, soft sounds filter in from far away, the air becomes saturated with the sweet smell of the earth. These times may last for just moments, or the moments may span an entire night or, more rarely, a day or several days.

Sometimes magical moments can be anticipated. In this instance, Rod waited a long time for twilight to settle on the waters of Lake Superior and the ancient hills cradling Old Woman Bay. The area had been visited earlier in the day by groups of tourists and fall birdwatchers, but by now everyone else had gone home. The soft pastel colors of this image are inviting, and the composition takes the viewer on a visual journey, around the nearest point of land and into the small bay farther back, then up tree clad slopes into the last dying rays of the setting sun.

CAMERA
Nikon F3

LENS
Nikon 300mm f/4

FILM
Professional Fujichrome 100

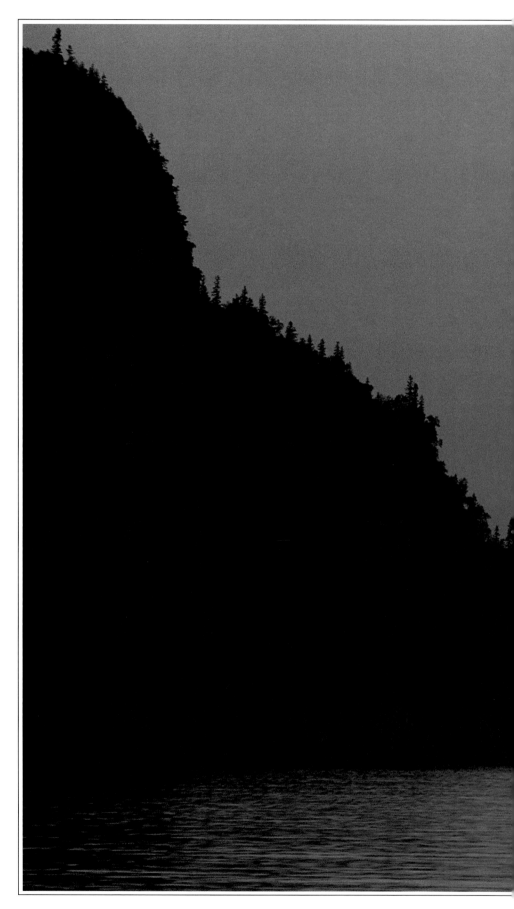

42

4: QUIET MOMENTS

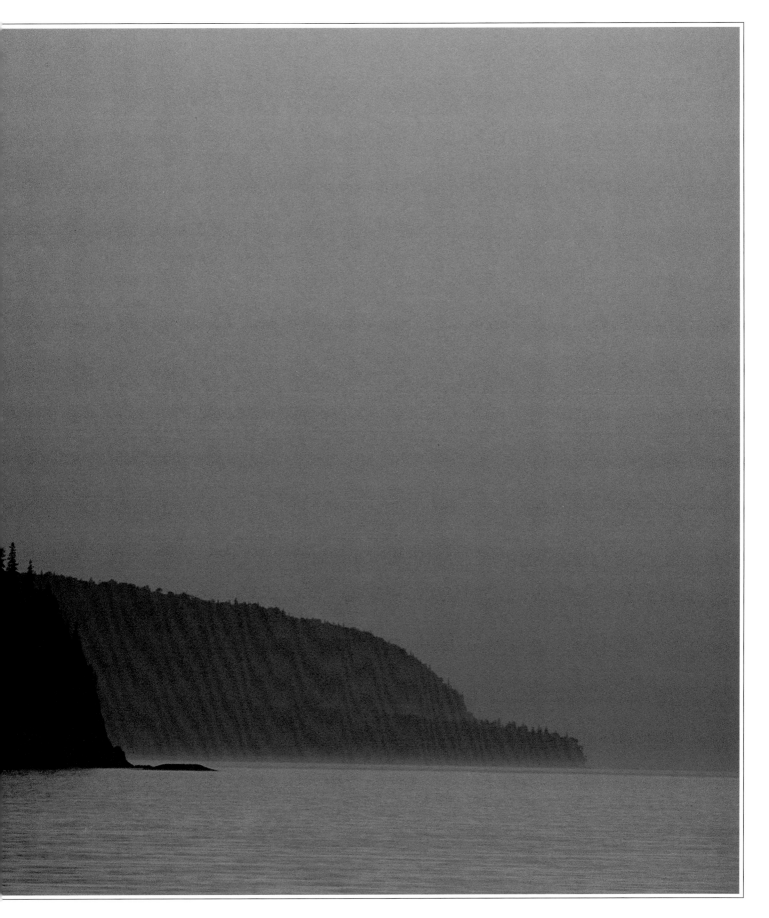

Drake wood duck, on a small vernal pond, Michigan

The calmest moments of each day tend to happen at dawn. Photographing ducks at this hour means getting into position well before daylight, then waiting for shapes to slowly materialize out of the dissolving darkness. In this instance, Rod used a natural drainageway as a blind, lying motionless in several inches of water at the grassy edge of a spring pond skimmed with ice. Cold and uncomfortable, he passed the time listening to roosters crowing from half a dozen distant farmhouses, across air so still it made them seem close at hand. Soon the familiar whistle of rapid wingbeats signaled approaching ducks, and they began dropping from the sky in small groups, unaware of his presence. A total of 40 to 50 wood ducks eventually accumulated, remaining for a short period of intensive feeding and courtship. The entire episode lasted less than an hour, terminated by their sudden departure for more protected daytime resting areas.

CAMERA
The Old Canon F1

LENS
Canon 500mm f/4.5L

FILM
Professional Fujichrome 100

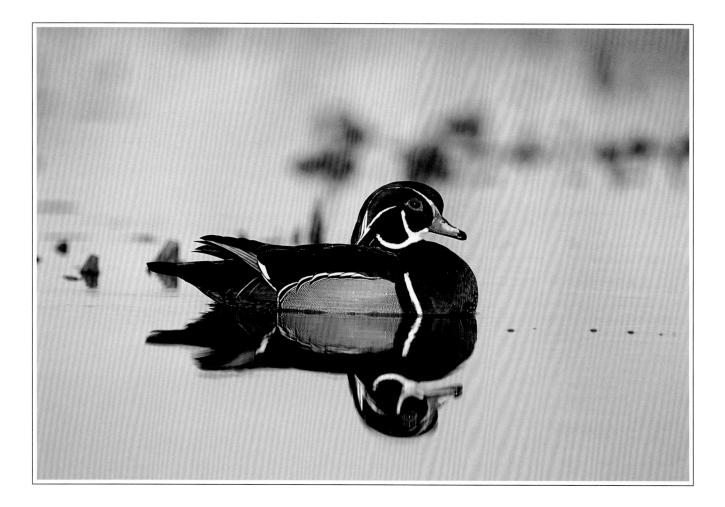

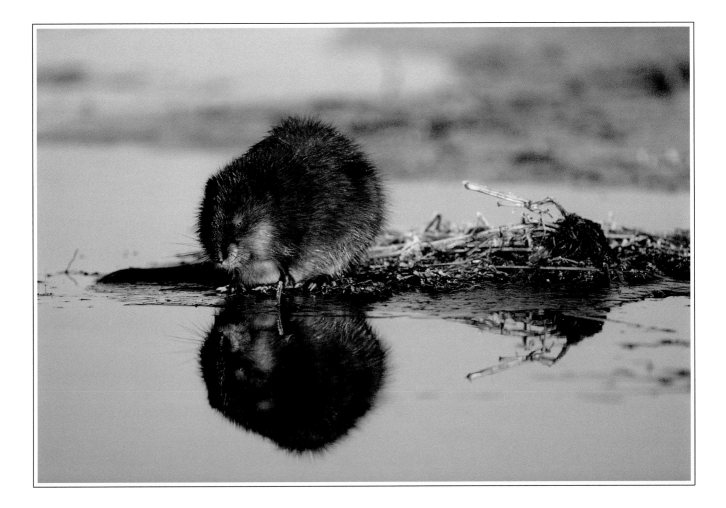

Muskrat at dawn, Michigan

Photographing nocturnal mammals is especially difficult under natural light conditions. Rod finally captured this image after spending 10 April mornings stalking muskrats by canoe, during the first couple of hours after sunrise. The long telephoto lens was supported on a tripod resting in the bow of the boat. Rod drifted in and out of river bayous on the calm water, scanning ahead for reeds signaling shallow mudflats. Upon spotting this muskrat through binoculars, Rod began the painstaking task of maneuvering to within camera range while remaining in full view of the animal. Twenty minutes later the canoe gently came to rest against the side of a sandbar, and with the camera thus stabilized, he clicked five frames before it slipped off and swam away.

CAMERA
Canon T90

LENS
Canon 500mm f/4.5L

FILM
Kodachrome 64

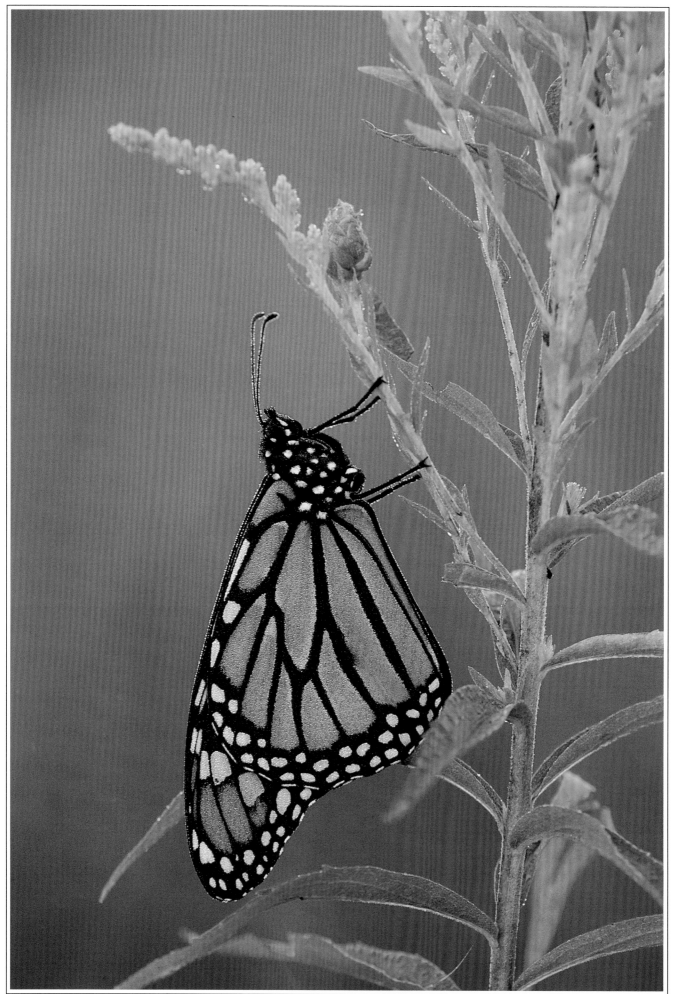

Monarch and dew, Michigan

Dew is a warm season phenomenon born of still air and temperatures cool enough at ground level to cause humidity to condense and plate the world with tiny water droplets. The dazzling result lasts for only a short while. The heaviest dews form in meadows and other openings, where heat escapes rapidly once the sun dips below the horizon. Monarchs are common in these types of places, seeking out milkweed plants on which to lay eggs. Several generations of monarchs leapfrog northward each spring from the southern United States and Mexico, eventually reaching the limits of milkweed in Canada by late summer. The last brood born there probably supplies most of the adults that make the long migration back to the overwintering grounds.

CAMERA
Nikon F4

LENS
Nikon 200mm f/4 Micro with a TC-14B 1.4 teleconverter

FILM
Fujichrome Velvia

Damselfly and dew, Michigan

Winged insects are held captive by dew, because the added weight of water makes flight impossible. The insects remain motionless until the morning sun rises high enough to burn off the dew, or until wisps of wind sweep across the meadow grasses. Creating an image of any dew-covered insect is a difficult process. The tripod becomes a cumbersome object that must be positioned delicately amid interwoven vegetation, so as not to shake the subject or its immediate surroundings. Here the photo opportunity was brief, because the droplet building above the damselfly's head eventually fell naturally and disturbed it.

CAMERA
Nikon F4

LENS
Nikon 200mm f/4 Micro with a TC-14B 1.4 teleconverter

FILM
Fujichrome Velvia

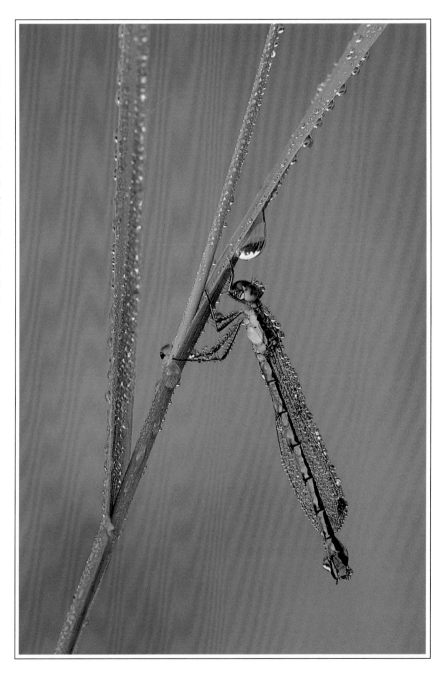

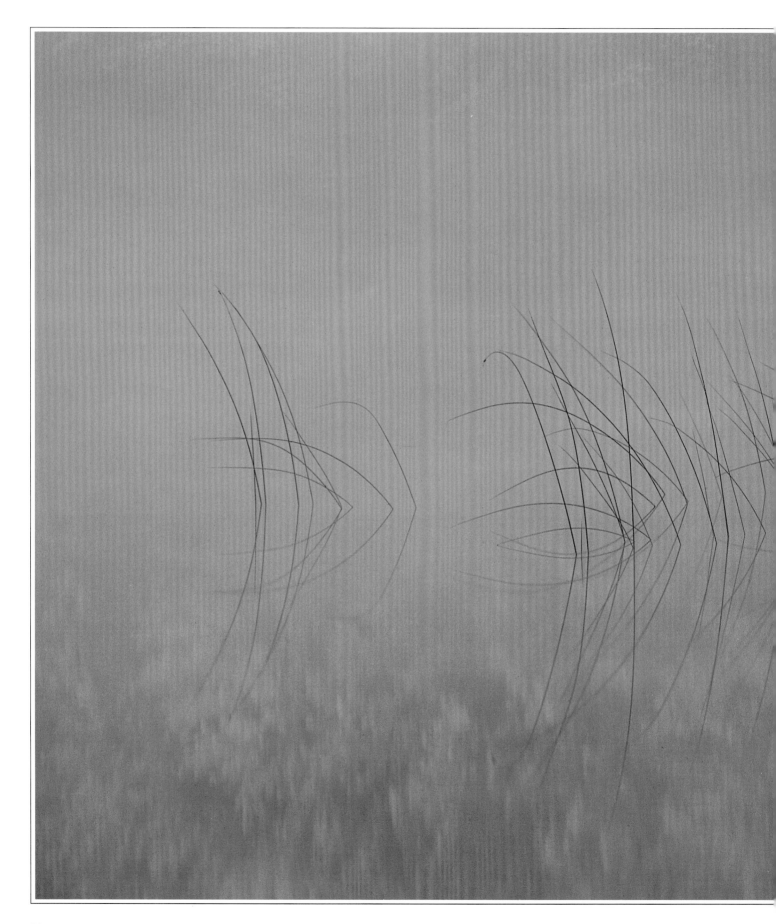

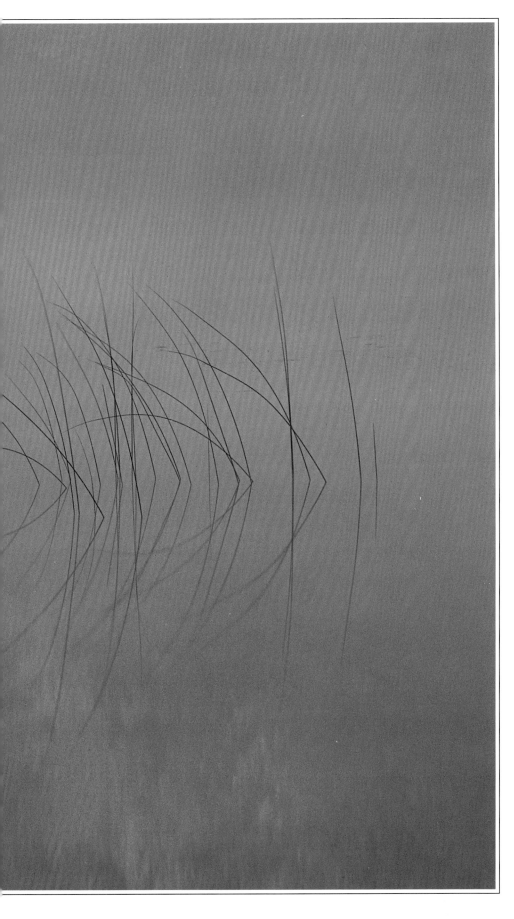

Fog and autumn reflections on a small lake, Michigan

Everyday objects or scenes are greatly simplified when seen through fog. Here a few slender reeds are juxtaposed against the reflection of early morning sunlight on the tops of colorful autumn trees. The background has the appearance of weaving in and out, as the reeds are touched and softened by an ever so slight breeze. This scene was recorded during one of Rod's photography workshops, and all the participants sensed the rareness of the moment. Five minutes after the photograph was taken, the breeze intensified and the fog dissipated, leaving a rather ordinary background crowded with detail. Rod has revisited the site several times, but has not taken another photograph there. The place remains the same, but the unique transformation of elements has never re-occurred.

CAMERA
Nikon F4

LENS
Nikon 200mm f/4 Micro

FILM
Fujichrome Velvia

Dusk, Old Woman Bay, Lake Superior Provincial Park, Ontario

The magical descent of twilight on Old Woman Bay, shown earlier in the opening photograph of this chapter, eventually led to this scene about a half hour after sunset. Darkness is now gaining momentum above, pushing the vestiges of daylight down below the crest of the headland across the lightly rippled water. The dwindling light was given ample time to collect on film through use of a 30 second exposure, resulting in rich color saturation and a pleasing range of blue and magenta hues.

CAMERA
Nikon 8008N

LENS
Nikon 55mm f/2.8 Micro

FILM
Professional Fujichrome 50

Fog along Lake Huron, Thompson Harbor State Park, Michigan

Dense fog adds an ethereal dimension to landscapes. This scene happened in late afternoon on a day characterized by stagnant weather, with banks of fog drifting continuously in and out from shore, pierced occasionally by warm rainshowers. All at once the air began to freshen, wisps of blue sky appeared overhead, and the sun poked through for the first time. The moment of transition passed quickly, and by evening the newly arrived cold front had fully dispersed the fog and clouds.

CAMERA
Canon EOS 10S

LENS
Canon EOS 24mm f/3.5L Tilt/Shift

FILM
Fujichrome Velvia

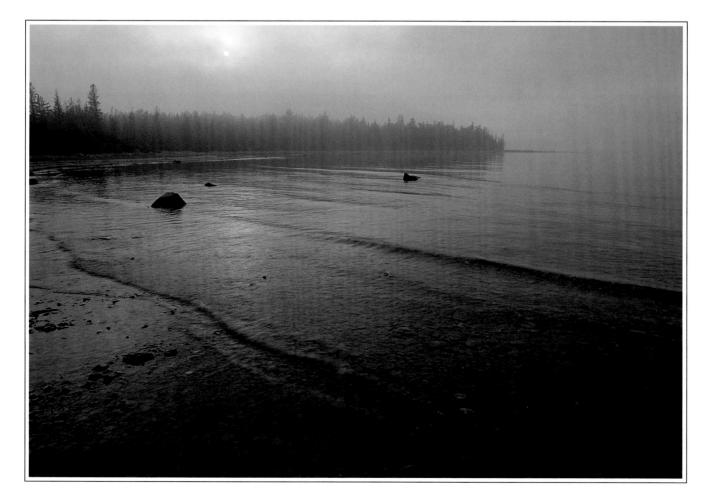

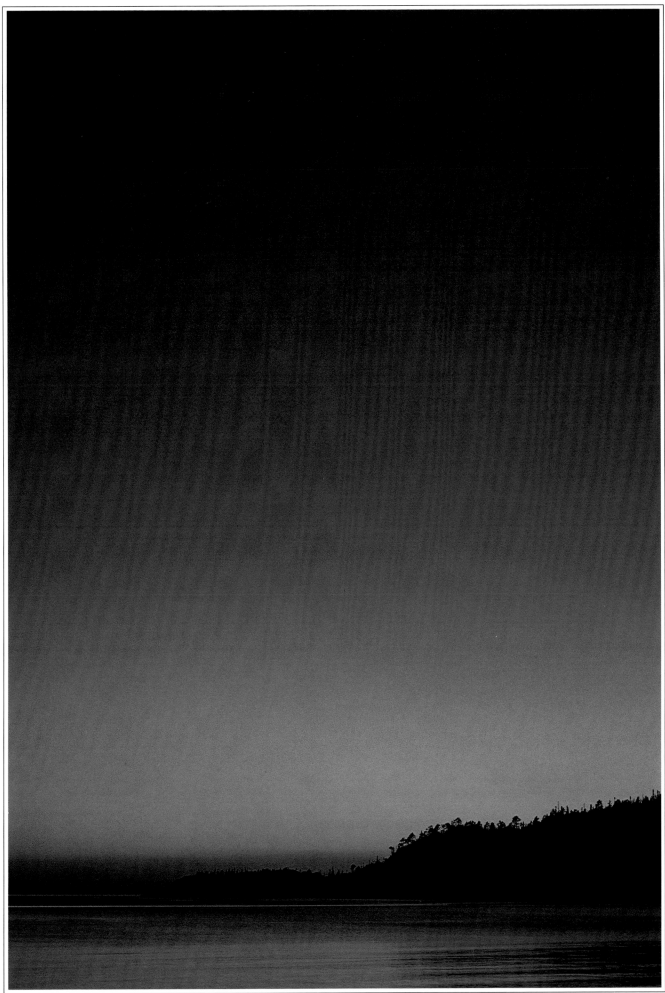

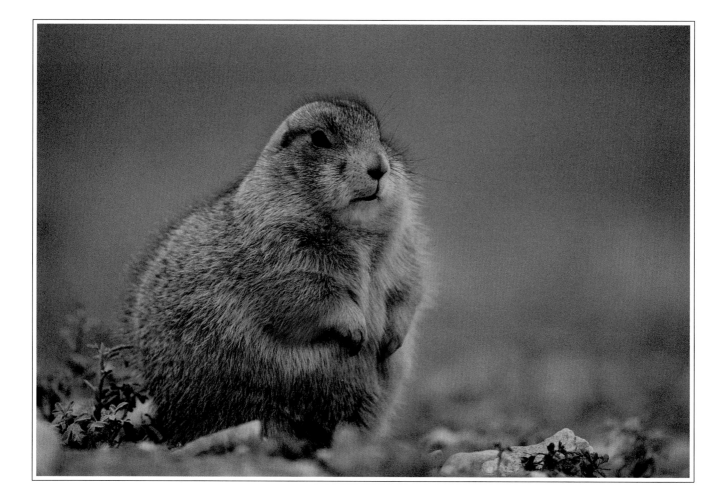

Black-tailed prairie dog, Wind Cave National Park, South Dakota

Amid the long and irregular transition of fall into winter there occasionally arises one special day that seems to mark the end of the old season. Photographer and subject both sensed this time of passing one prairie evening in late October. The day had been exceptionally warm and windless, but now a curtain of clouds hung over the western horizon. Rod had spent the entire morning becoming familiar with this prairie dog, a chubby young adult about to enter its first winter. Returning in early evening, Rod carefully crawled to within about 10 feet of the same animal as it sat placidly just outside its burrow entrance. The two faced each other for some time in the dying light, until the prairie dog finally disappeared underground. At nightfall the coyotes called long and loud, from every direction. The next day it snowed.

CAMERA
Nikon F3

LENS
Nikon 300mm f/4

FILM
Professional Kodachrome 200

*Paintbrush and milkvetch,
Colorado National Monument,
Colorado*

Wind is a constant feature of rugged plateau country, as much a part of the landscape as buttes, canyons and crags. At times the wind is wonderfully breeze-like, but more often than not it blows stiffly and steadily for days on end. The monotony is annoying and can drive a person crazy. The wind had been blowing in just such a manner, both day and night, before this photograph was taken. Then, without warning, it completely died. Suddenly the hum of millions of desert no-see-ums began to rise on the breathless air. Gray flycatchers and gray vireos began singing from inside nearby groves of pinyon pine and juniper, and the chatter of black-throated swifts re-sounded through the darkening skies over-head. The lull sharpened the fine details of the red paintbrush, yellow milkvetch and encompassing plants shown here.

CAMERA
Canon EOS 10S

LENS
Canon EOS 90mm f/2.8 Tilt/Shift

FILM
Fujichrome Velvia

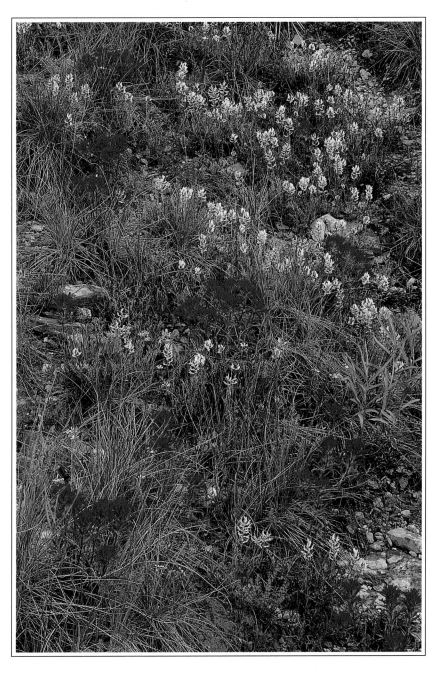

Maple tree, first snow, Michigan

Winter is a time of great reduction and simplification. As snow envelops the land, old details disappear and new lines are formed by the hand of the wind. The results are often dramatic, as shapes and textures become more apparent in the absence of bright colors. The season imposes a challenge on most animals, and a majority become dormant or hibernate or migrate to avoid harsh conditions. The few that remain active tend to concentrate around food sources. Winters are highly variable, and in some years the countryside is alive with birds and mammals, bolstered by great numbers of visitors from the north including finches and owls. In other years the countryside is devoid of life, and several hours of searching may yield only a couple of ravens or a lone rough-legged hawk.

Winter usually arrives with a snowfall that is extremely wet and sticky. Rod drives back roads at this time of year, looking for simple images like this maple tree growing in an old field. The heavy snow has helped to erase the superfluous details of grasses and brambles growing underneath the tree, while at the same time adding depth to the web-like barren branches. Rod instructs students to strive for simplicity in order to strengthen photographic composition.

CAMERA
The Old Canon F1

LENS
Canon 50mm f/3.5 Macro

FILM
Kodachrome 25

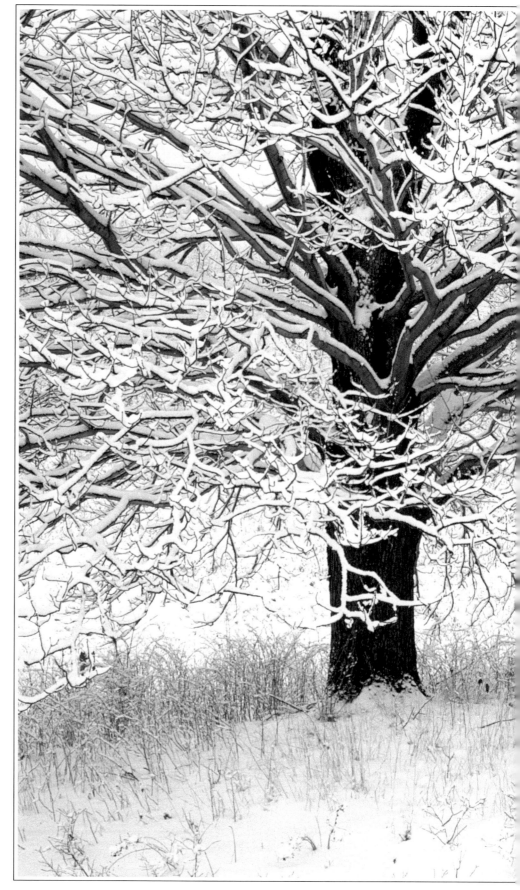

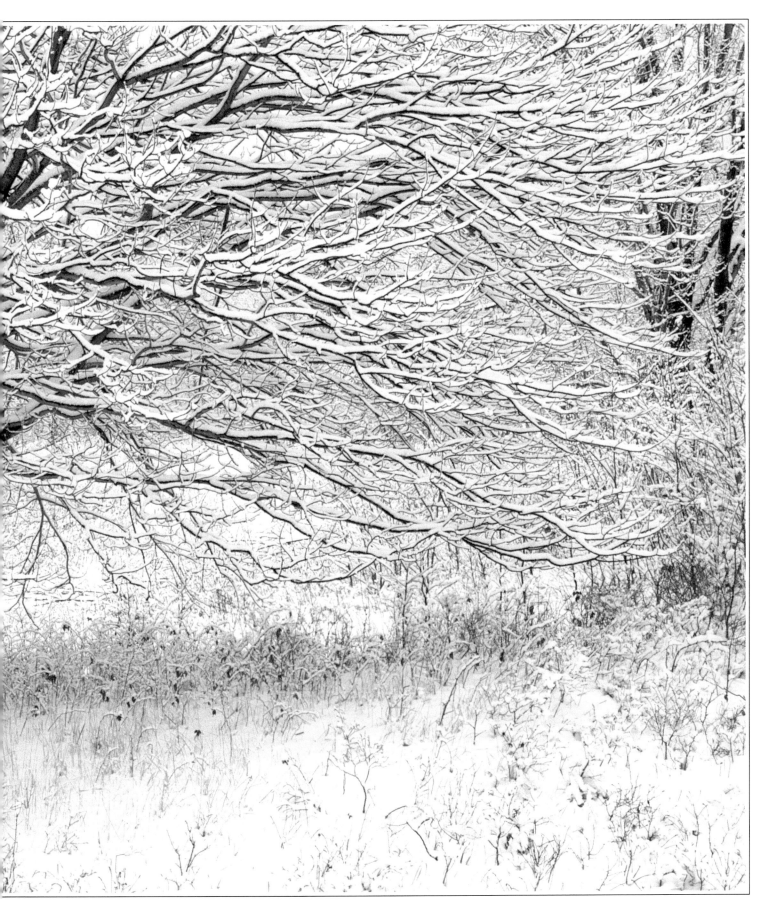

Snow and sun, Yellowstone National Park, Wyoming

This photograph also captures the essence of an early season snowfall. On this day flakes the size of quarters came pouring down from the veiled sky, at first melting instantly upon contact with the earth but then quickly accumulating into a thin, dense layer. The sun appears to be shining brightly over the mountains on the other side of the Lamar River, which flows just beyond the barely discernible fringe of trees.

CAMERA
Canon EOS 10S

LENS
Canon EOS 45mm f/2.8 Tilt/Shift

FILM
Fujichrome Velvia

Hills and sky, Yellowstone National Park, Wyoming

Simplicity is maximized in this composition. Rod concentrated on the sensuous shape of the two hills and intervening pass, brought out by the blue sky behind. He was able to accentuate the late afternoon sky by using a polarizing filter. The scattered clouds add just enough detail to keep the image from being too plain.

CAMERA
Canon EOS 10S

LENS
Canon EOS 45mm f/2.8 Tilt/Shift

FILM
Fujichrome Velvia

Snowshoe hare, Upper Peninsula, Michigan

The snowshoe hare is extremely well-adapted for winter survival. Its coat changes annually from brown to silvery white during the time of first snow. Its large eyes and sharp ears are always tuned in to the movements of predators, and the padded hind feet allow good traction in soft powder should a speedy escape be necessary. This one is shown grooming a hind foot, a necessary task to keep ice from building up between the dense stiff hairs of each pad. Snowshoe hares usually feed at night, and spend the day resting motionless in shelter afforded by dense clumps of young evergreens or the tangled branches of toppled trees. This photograph was taken late on an overcast day, after Rod had spent many hours stalking several different hares. Rod was lying flat at the time, with the tripod jammed all the way up to the camera mount in deep snow, when the hare reversed its meandering course and hopped directly into view.

CAMERA
Nikon F3

LENS
Nikon 500mm f/4

FILM
Professional Kodachrome 200

Englemann spruce trees, Yellowstone National Park, Wyoming

Although appearing to be seedlings, these two spruces growing close to one another are actually buried in five feet of snow. Aside from its pleasing simplicity, Rod likes this image because he can envision songbirds building nests in the trees at a different time of year, when the snowpack is gone and the underlying alpine meadows are full of wildlife and carpeted with ephemeral summer wildflowers.

CAMERA
Canon EOS 10S

LENS
Canon EOS 24mm f/3.5L Tilt/Shift

FILM
Fujichrome Velvia

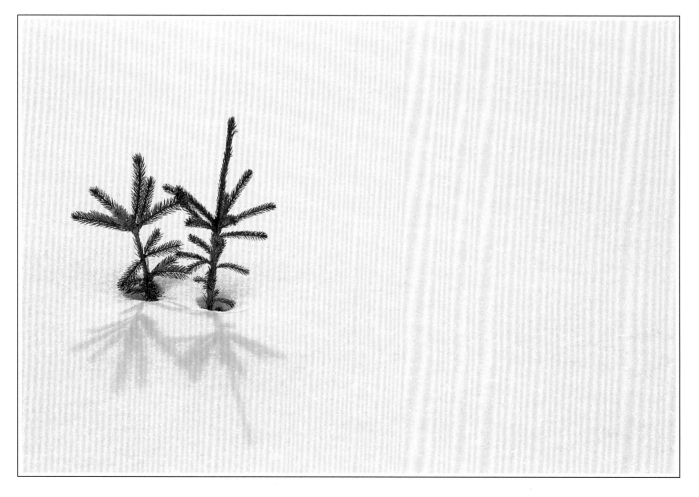

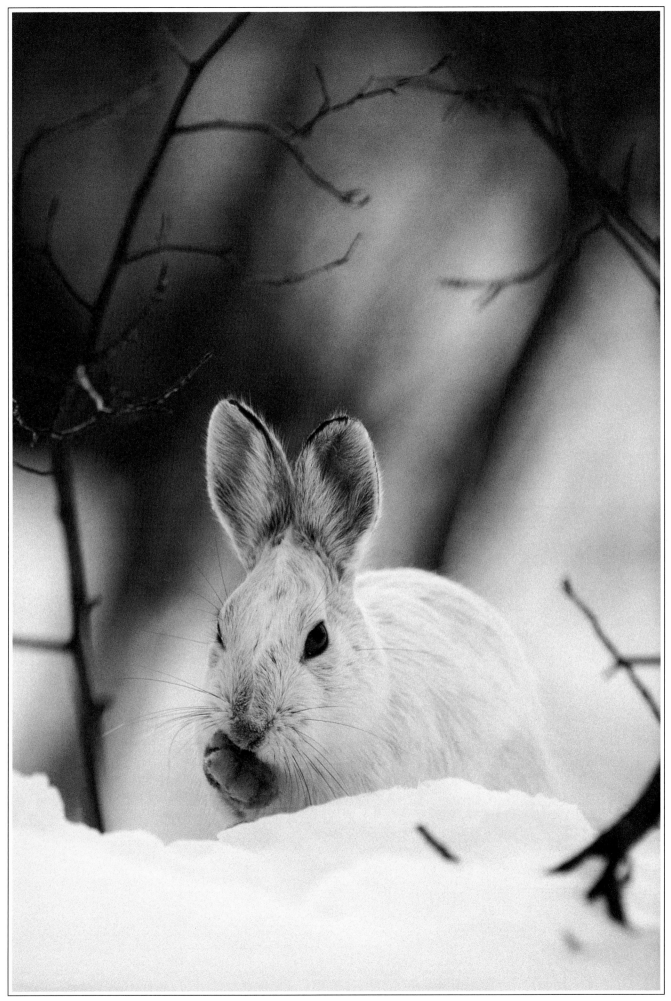

Glaucous gull on the attack, Michigan

Open water often attracts large and diverse numbers of birds during winter. Up to nine gull species may be present at one time along this stretch of the Saginaw River, inside the limits of Bay City. Up to 13 species have been recorded at Niagara Falls during the same early winter time period. The robust glaucous gull shown here is battling for a gizzard shad held by a smaller herring gull located just outside the frame. Glaucous gulls spend the summer in the high Arctic, eating the young of other birds and scavenging on kills made by polar bears. They scatter in late fall and rarely wander farther south than the Great Lakes, occurring singly or in small groups of less than 10 birds. Rod has a passion for gull-watching, and he makes special trips each year to these concentration meccas. He spends considerable time composing instructional photographs of the different species, in an effort to raise public awareness of their diversity and interesting nature.

CAMERA
Nikon F4

LENS
Nikon 500mm f/4

FILM
Professional Fujichrome 100

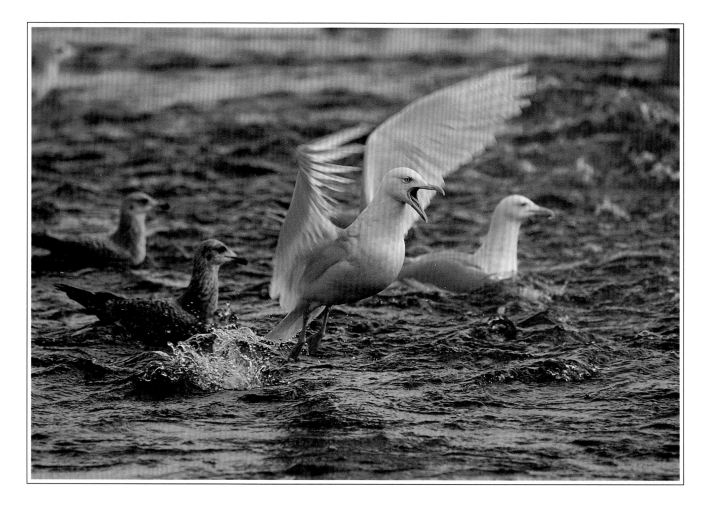

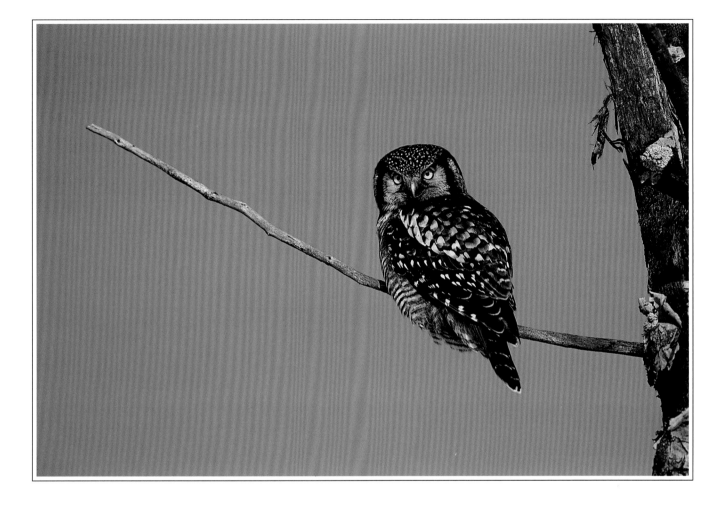

Northern hawk-owl, Upper Peninsula, Michigan

In certain winters dozens or even hundreds of northern owls descend out of the boreal forest to congregate around fields and clearings across the upper Great Lakes region. The invasion may involve northern hawk-owls, great gray owls, snowy owls or any combination thereof, and is believed to be precipitated by cyclic crashes of small rodent prey populations. The northern hawk-owl is so named because it bears the appearance of an owl but often hunts during the daytime from a high perch, like a hawk. Rod tried to photograph this individual for three days but it always remained out of camera range. Finally, on one occasion, Rod looked back while walking away and saw the bird sitting in his footprints. It had apparently dived into the snow after a meadow vole, and missed. The hawk-owl then flew to the first available limb, only 20 feet away from Rod.

CAMERA
Nikon F4

LENS
Nikon 500mm f/4

FILM
Fujichrome Velvia pushed one stop

Snowy owl mantling prey, Michigan

During most winters, snowy owls appear in small but regular numbers scattered across the northern United States. The birds may begin arriving as early as November in Michigan. Rod had been following the daily movements of several at this time of year when he became more interested in this one, which frequented a breakwater jetty made up of large limestone boulders extending into Lake Huron. About 45 minutes before this photograph was taken, Rod watched the bird sail out over the open harbor and casually pluck a horned grebe off the water's choppy surface. The owl returned immediately to its perch and assumed this hunched posture, known as mantling, which likely is a behavior aimed at shielding the carcass from other predators or potential robbers. Rod then spent 30 minutes approaching the bird through chest deep water, without waders, to get this close. Several days later, after the owl departed the area, Rod walked out to where it had been sitting. He found 8 pairs of horned grebe feet, and a pair of feet plus one wing that formerly belonged to a black scoter.

CAMERA
Canon T90

LENS
Canon 500mm F4.5L with a Canon 1.4 teleconverter

FILM
Professional Fujichrome 100

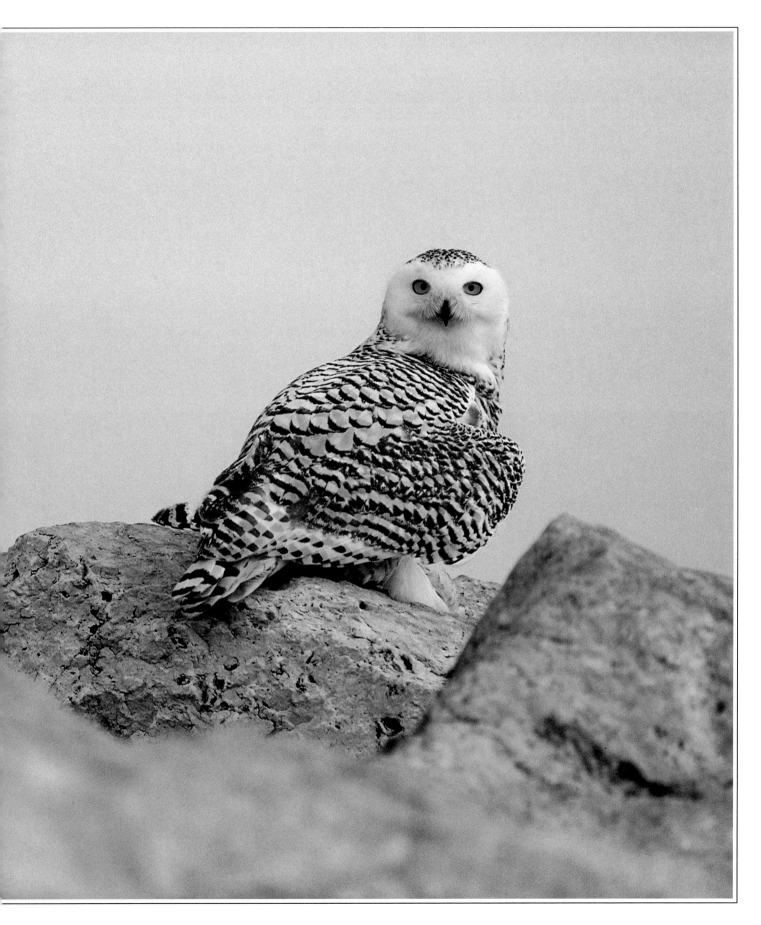

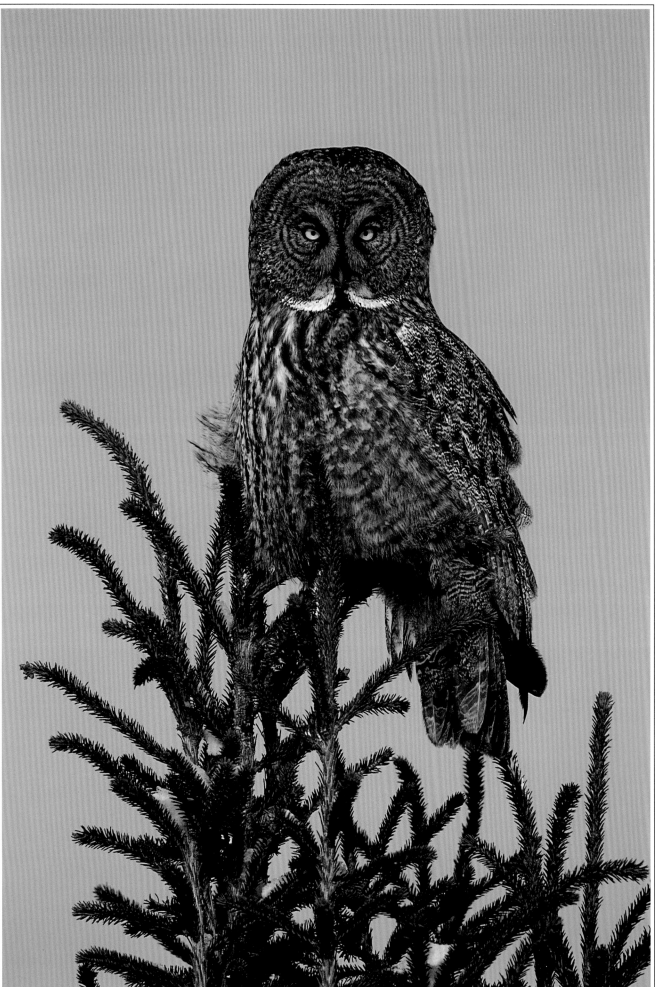

Great gray owl, Upper Peninsula, Michigan

The great gray is the largest North American owl in terms of finished dimensions, although much of its imposing size is attributed to a thick layer of soft feathers that provides exceptional insulation. Each large facial disk acts like a parabolic reflector, catching faint sounds made by rodents moving under the snow and greatly magnifying them. This helps the owl to pinpoint prey that may otherwise remain invisible, especially in the boreal forest where powdery snow accumulates to a depth of several feet or more. The owl attacks the prey in these situations by making a characteristic feet first plunge into the deep snow.

Astonishing numbers of great gray owls appeared during the winter of 1992 in the northern Great Lakes region. The year will be remembered as one of the best ever for seeing the birds in Michigan. Rod and Marlene spent seven days with the trusting birds in early February of that year, in the countryside just outside the town of Sault Ste. Marie. They were on snowshoes from dawn to dusk each day, often in bitter weather, and became closely acquainted with more than a dozen individuals. One in particular, shown here in both photographs and nicknamed "Big Baby Mama", seemed especially photogenic. Big Baby Mama, as the name implies, was a large female that frequented the edge of an old apple orchard near an abandoned farm. She was extremely animated and vocal, and she constantly drove other owls away from her hunting grounds. Many of the owls routinely allowed people to walk to within about 20 feet or less of where they were perched, making for a unique and memorable natural experience.

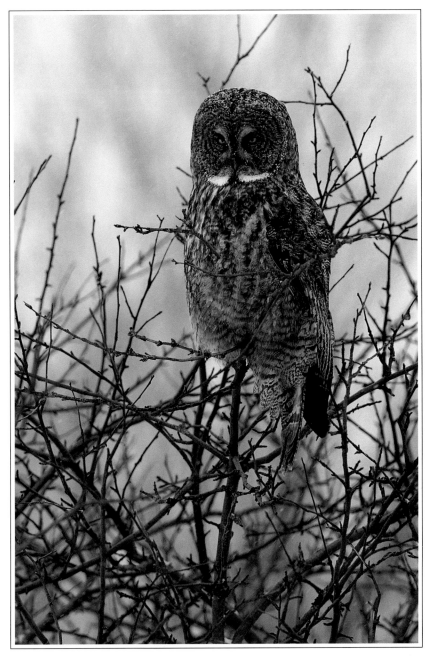

CAMERA
Nikon F4

LENS
Nikon 500mm f/4

FILM
Fujichrome Velvia pushed one stop

Muscid fly in Rod's backyard, Michigan

The immensity of space is purely a matter of perspective. A fly's world, for example, may never reach beyond the limits of a backyard, leaving the rest of the earth a vast frontier. The fly itself may form the same sort of limits for a tiny parasite that spends its entire short life riding around on the fly's body. A human's world, on the other hand, can now encompass much of the globe due to the ease of air travel, making the earth seem considerably smaller than it appeared to be just a hundred years ago.

Time is also an immensity. Its steady passage can be measured in terms of fractions of a second, which is what it takes for a fly to do a forward barrel roll and land upside down on the underside of a leaf, or in millions or even billions of years, the time it takes for most rock formations to be created. It is humbling to realize that, despite our seeming self importance and the hectic pace of everyday life, our lives will begin and end in less than a microsecond of the time that has elapsed since the earth began.

CAMERA
The Old Canon F1

LENS
Canon 200mm f/4 with a Minolta 100mm f/4 Short Mount reversed on front

FILM
Kodachrome 25

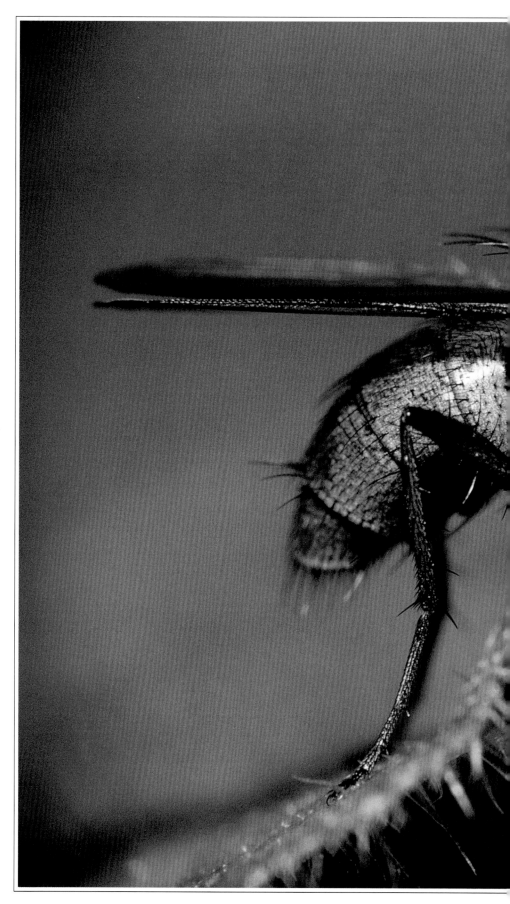

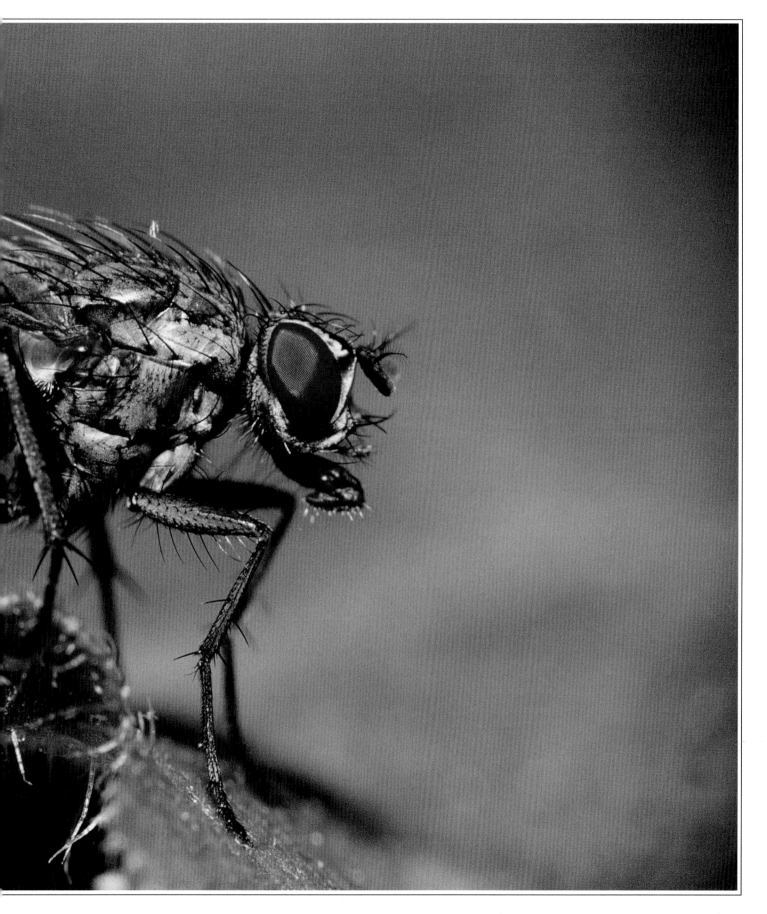

Jumping spider in Rod's front yard, Michigan

The edge of a leaf may seem like the top of a deep chasm to this one-eighth inch long jumping spider known in the scientific world as *Evarcha hoyi*. The spider traverses these open spaces by hopping from leaf to leaf, while simultaneously spinning a single strand of web that serves as a safety line if it misjudges a destination or becomes blown off course. Jumping spiders roam about in search of prey, relying on the depth and motion perception afforded by four pairs of simple eyes to make the final killing leap. Rod stalks these small creatures in the same manner as large ones, but he uses considerably different equipment. The camera is not supported by a tripod and is mounted instead on a handheld frame. For this photograph and the previous one, Rod used a 200mm lens with a second 100mm lens mounted in reverse on the front, which together provided 2X magnification. The jungle-like habitats frequented by the tiny creatures make it almost impossible to photograph them under natural light conditions. Thus electronic flash was needed to adequately illuminate the subject.

CAMERA
The Old Canon F1

LENS
Canon 200mm f/4 with a Minolta 100mm f/4 Short Mount reversed on front

FILM
Kodachrome 25

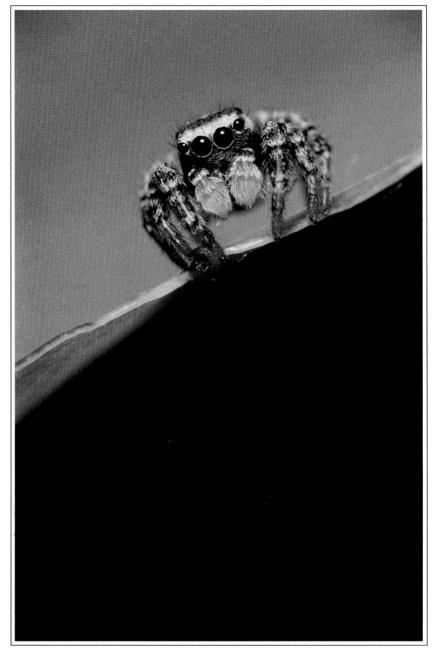

Drifting sand, Great Sand Dunes National Monument, Colorado

The tiny speck in the lower right hand corner of this photograph is a person, who likely felt an appreciation for the immensity of space after scaling this giant dune. Wisps of sand can be seen lifting off the peaks, and what appears to be sky is really a rising cloud of dust, obscuring the base of a mountain range normally visible in the distance. Rod saw no hope of taking photographs on this particular day in late spring, because of the violent wind, but he happened to drive by at just the right time. He huddled behind his vehicle, out of the wind, and set up two tripods, one supporting the camera body and the other the long telephoto lens, in order to reduce vibrations.

CAMERA
Nikon F4

LENS
Nikon 500mm f/4

FILM
Fujichrome Velvia

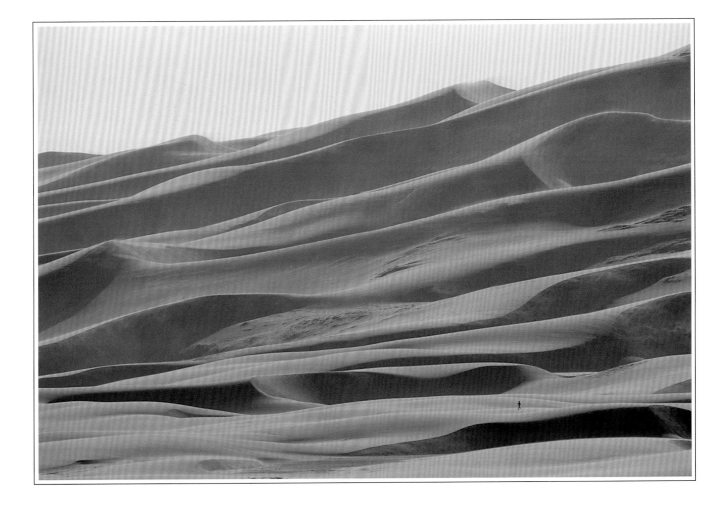

Ancient bristlecone pine tree, White Mountains, California

The red cast to this bristlecone pine was created by late afternoon sunlight striking airborne dust particles. The antler-like shape and warm light created a potential subject that appealed to Rod but proved difficult to compose. He elected to use a 200mm lens to tighten the frame and enhance the contrast between dead branches and sky.

CAMERA
Nikon F4

LENS
Nikon 200mm f/4 Micro

FILM
Fujichrome Velvia

Ancient bristlecone pine tree, White Mountains, California

Bristlecone pines are the oldest known living things. A few extant individuals are believed to have sprouted more than 4000 years ago, or about 2000 years before the time of Christ. The complexion of the earth's face has changed dramatically during that span. Yet the ancient trees live on, in relative obscurity at high altitudes, feeling little direct effect from the changes other than breathing in air that has become more polluted in recent years. Bristlecone pines typically look more dead than alive, which is key to their longevity. Only a portion of the tree is active at any one time, making it easier to survive the harsh conditions and short growing season imposed by the alpine environment. Rod used a wide-angle lens in this instance to keep the gnarled tree proportional in size to both the wide open sky behind and the talus slope in which it is anchored. These are integral components of the bristlecone pine's life history, and they work here to balance the composition as well as tell part of the story.

CAMERA
Nikon F4

LENS
Nikon 24mm f/2.8

FILM
Fujichrome Velvia

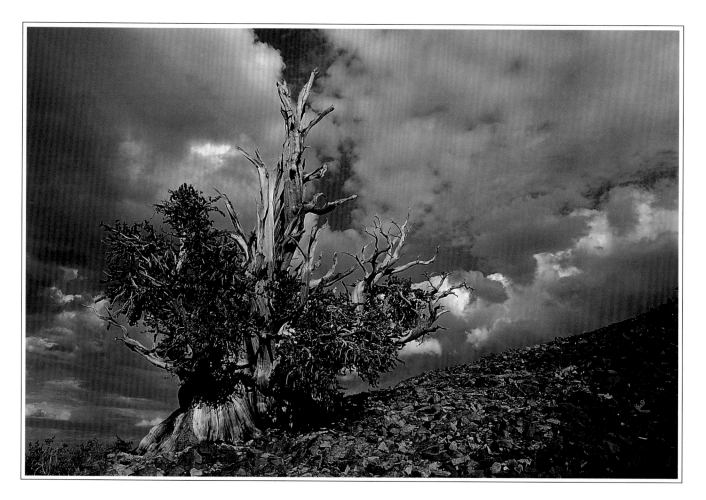

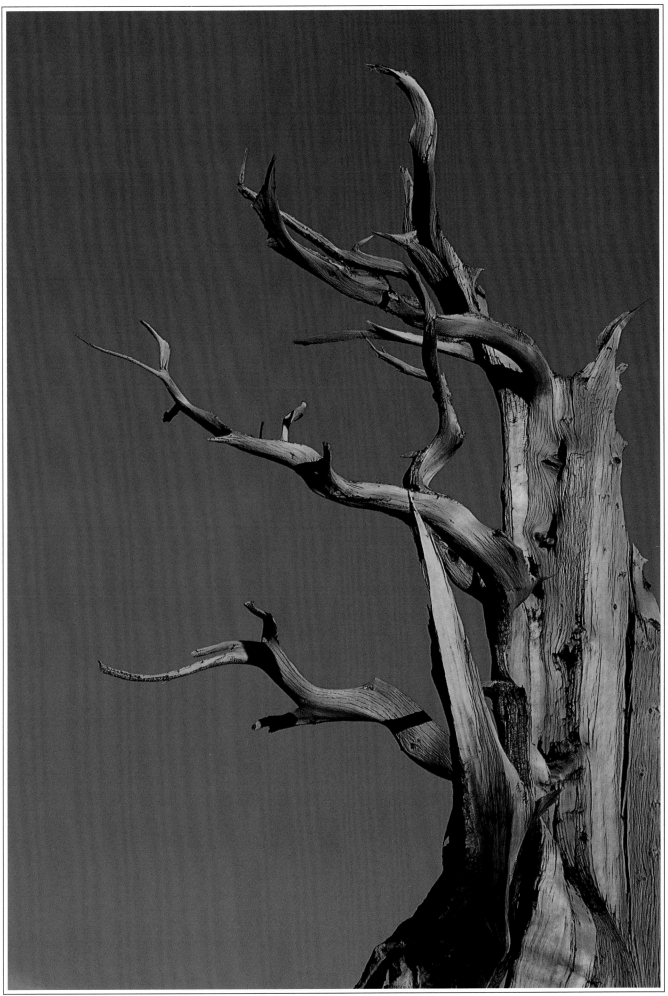

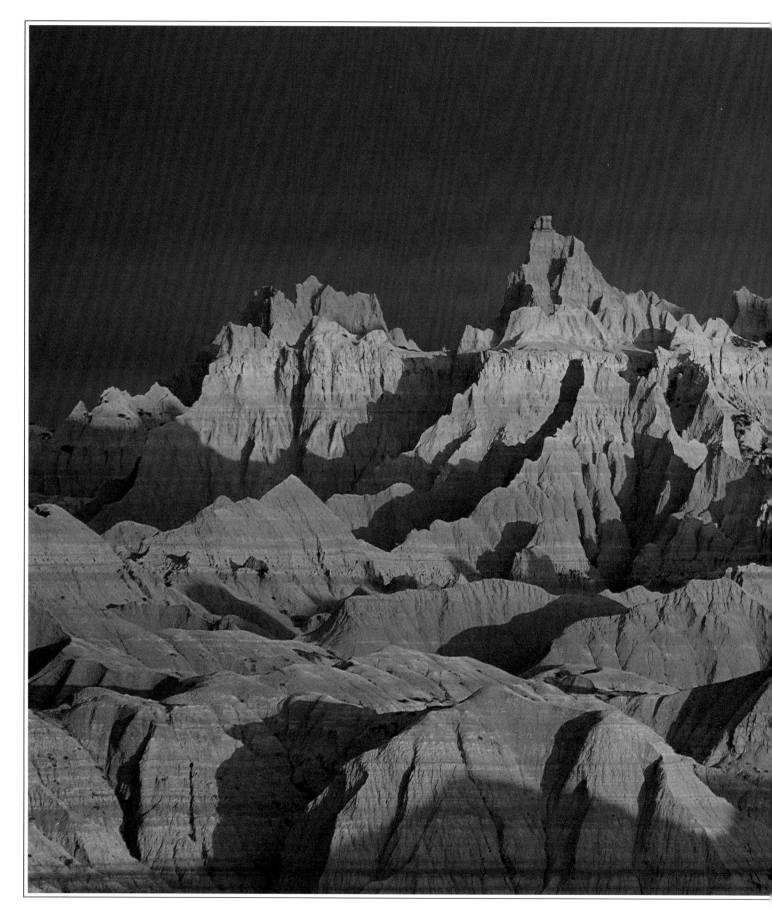

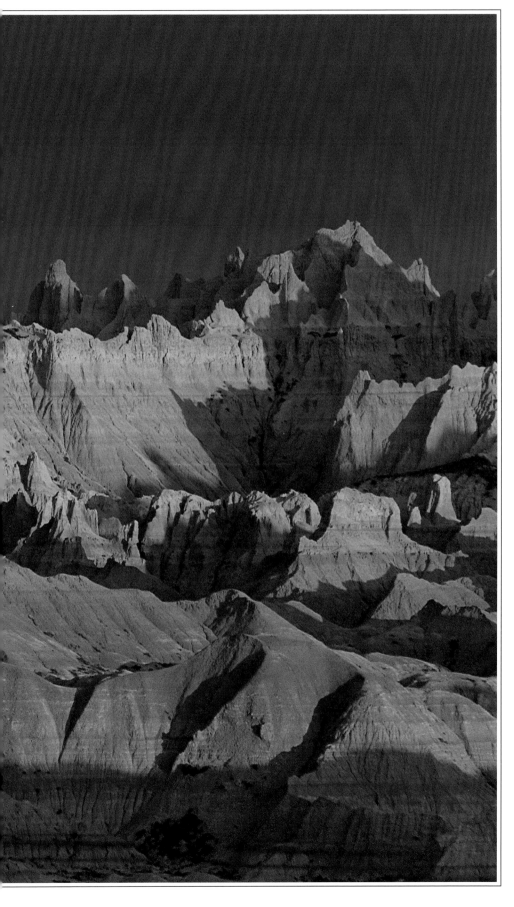

Thunderstorm at dawn,
Badlands National Park,
South Dakota

Time and the forces of erosion have transformed the Badlands into a ruinous landscape. Within these ragged hills of dust lie the abundant remains of ancient organisms, fossilized in layers of sediment that were deposited between 80 and 22 million years ago. The land gradually uplifted over that period, starting as a shallow productive sea that became a region of beaches and deltas, then wooded hills interspersed with tropical swamps. A dusting of ash from volcanos to the west and southwest is still visible as the whitish layer near the top of some of the formations, marking the end of the major depositional episodes. Climatic conditions became cooler and drier after that, and a period of downcutting began that continues today. On this particular morning the peaks are lit by the rising sun, as the camera faces due west into an oncoming storm. The unique light only lasted for about 30 minutes.

CAMERA
Nikon F4

LENS
Nikon 500mm f/4

FILM
Fujichrome Velvia

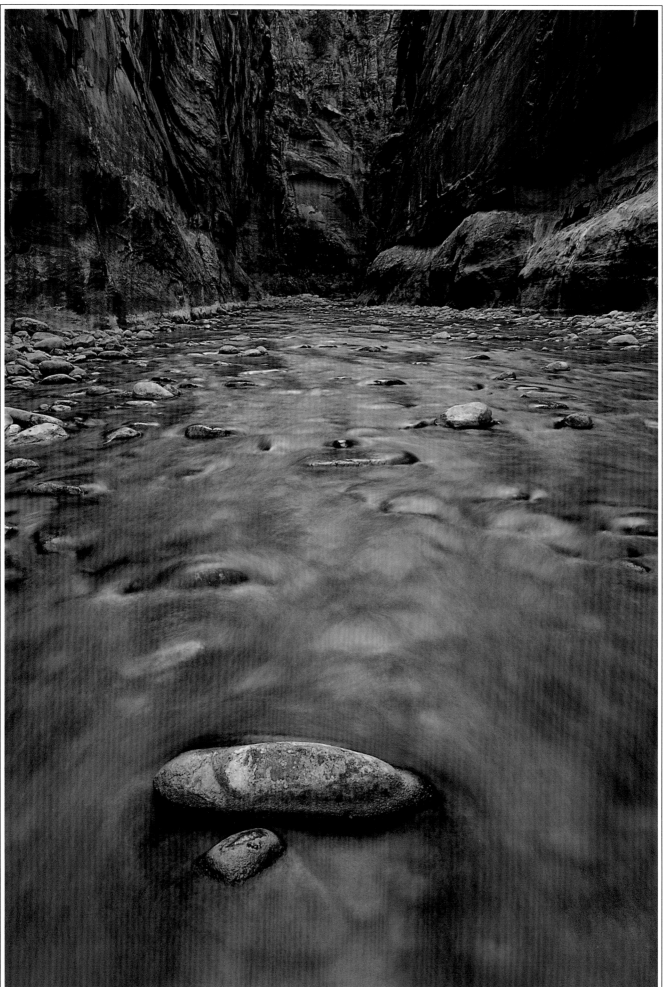

Virgin River Narrows, Zion National Park, Utah

Eons ago, the Virgin River ran more than a thousand feet directly above this spot. Since then the endless flow has carved through many layers of Navajo Sandstone, creating the deep gorge that is now called the Narrows. The fine-grained sandstone is soft enough to give way to the water but hard enough to keep the newly formed walls from collapsing. The river itself is now a popular hiking trail, which seems to present a photo opportunity around every bend. Rod stood ankle deep in water to frame this image, using a wide-angle lens to portray the continuity of the river in relation to the worn rock faces it created. A 30 second exposure at f/22 helped impart a feeling of motion to the water curving around the rock in the foreground, with sufficient depth of field to retain sharp detail in the background.

CAMERA
Canon EOS 10S

LENS
Canon EOS 24mm f/3.5L Tilt/Shift

FILM
Fujichrome Velvia

Ancient tidal pool, Capital Reef National Park, Utah

Standing water is another means by which erosion changes the shape and texture of rock formations. The surface of this slab was pitted through long exposure to periodic rains and snowmelt. Precipitation contains a small amount of hydrochloric acid which dissolves calcium carbonate, the cement that binds sandstone together. The loosened sand grains are eventually washed or blown away, leaving behind numerous shallow depressions. Water continues to collect in these small depressions over time, perpetuating the erosional process.

CAMERA
Canon EOS 10S

LENS
Canon EOS 90mm f/2.8 Tilt/Shift

FILM
Fujichrome Velvia

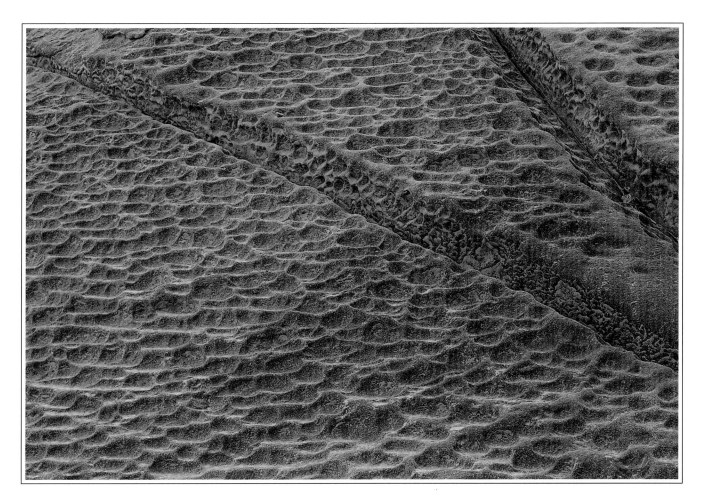

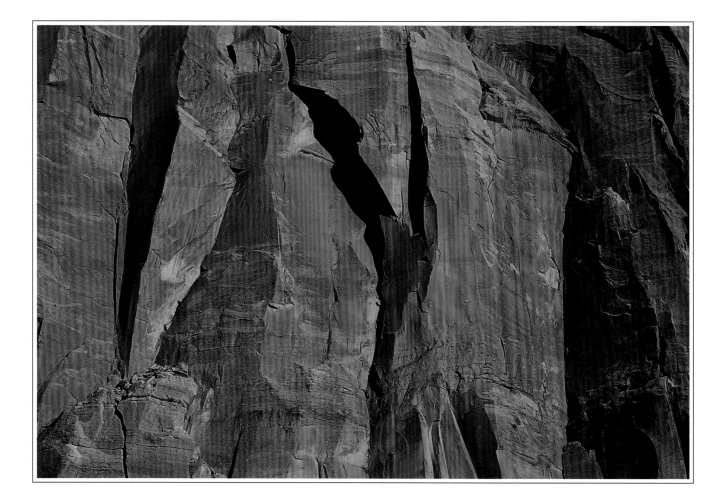

Wingate Sandstone wall, Capital Reef National Park, Utah

History is indelibly written on the spare landscape of the American South-west. This uneven rock face, for example, was once the inside of an ancient dune thousands of feet high, deposited by wind along the coast of a large inland sea. The lower layers of the dune were eventually compressed into a loose-knit sandstone, during a time when the sea rose up and covered much of what is now the Colorado Plateau. The irregular cracks on the rock face spell out the more recent effects of freezing and thawing, which can force large blocks to peel off. The relatively high rate of collapse is driven by a softer underlying formation, which erodes faster and thus continually undercuts the layer shown here. Every crack in this imposing wall tells an interesting story, about an immense geologic journey begun eons ago. And the journey is far from over.

CAMERA
Canon EOS 10S

LENS
Canon EOS 45mm f/2.8 Tilt/Shift

FILM
Fujichrome Velvia

Navajo Sandstone mesa, Utah

Navajo Sandstone deposits, which occur above the Wingate layer, are also petrified dunes. The forces of erosion have gently sculpted the exposed formations of Navajo Sandstone into smooth rounded shapes that are commonly called "slickrock". The interesting checkerboard appearance shown here is the result of erosion occurring at different rates on several fronts. The effects are most pronounced in the vertical joints that formed when the sandstone was uplifted long ago, and slightly less so at the horizontal interfaces between cross beds, originally created when one layer of sand grains was blown over the top of another. The overall pattern is similar in some respects to that of the cracked mud in Chapter 2, but whereas cracked mud is temporary and disappears with the next major rainfall, this sandstone may outlast the human race.

CAMERA
Canon EOS

LENS
Canon EOS 45mm f/2.8 Tilt/Shift

FILM
Fujichrome Velvia

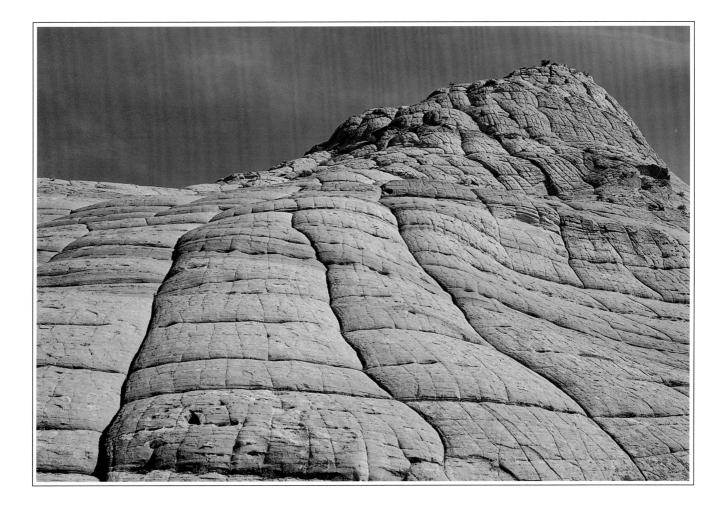

Virgin River Narrows,
Zion National Park, Utah

There are passages throughout nature. Some involve a significant physical journey from one place to another, like water flowing down a river, or birds that instinctively follow age-old routes to and from roosting areas or between breeding and wintering grounds. Others relate to the subtle but magical transformation of youth into adult. All such passages, whether oriented to place or growth or both, are set in a larger framework of time as meted out by the changing seasons.

Rod stood chest deep in water and used a one minute exposure at f/22 to capture this image. The green cast to the river is natural, and did not result from a color shift due to the long exposure. During the time the camera shutter remained open, an American dipper flew through the frame and on up the narrow corridor to the right, all the while singing a melodious, cascading song that echoed through the canyon long after the bird disappeared.

CAMERA
Canon EOS 10S

LENS
Canon EOS 24mm f/3.5L Tilt/Shift

FILM
Fujichrome Velvia

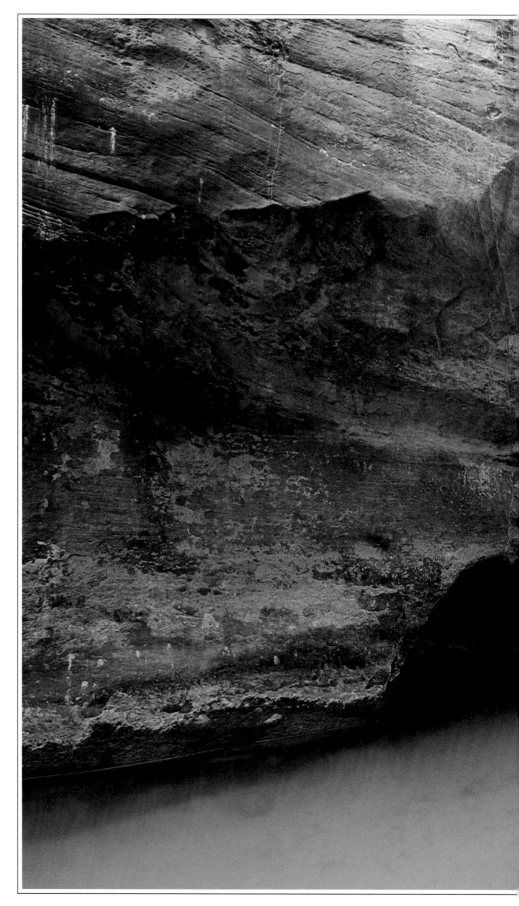

7: PASSAGES

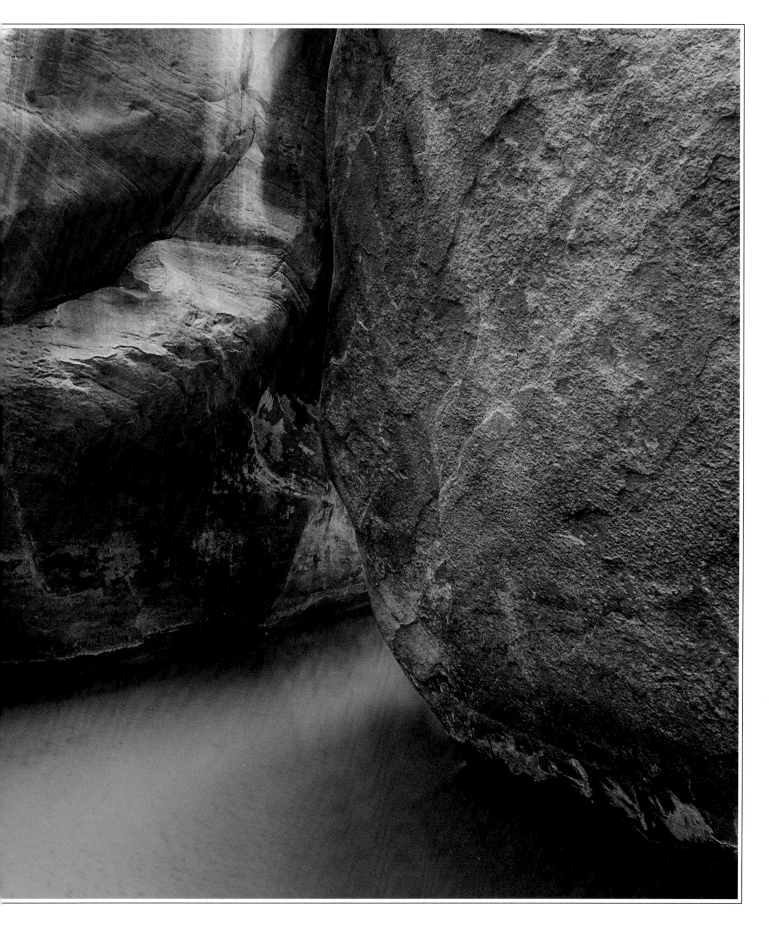

Drake mallard leaping from a small vernal pond, Michigan

Dabbling waterfowl often move several times each day. The first trip is to feeding grounds that are more productive than the safer water of the roost site. After eating, the ducks may rest in the back corner of a cattail marsh until late afternoon or evening, when it comes time to feed actively again. A number of mallards made daily stops at the small pond where Rod photographed the ducks shown in earlier Chapters. This drake dropped down to drink water and take gravel, after having first fed in a stubble field nearby. The gravel is needed for digestion, remaining temporarily in a muscular digestive organ called the gizzard which grinds food. Rod studied the drake's behavior carefully and anticipated this lift off. After reviewing the film, he realized that the bird carried a metal band barely visible on the right leg.

CAMERA
The New Canon F1

LENS
Canon 500mm f/4.5L

FILM
Professional Fujichrome 100

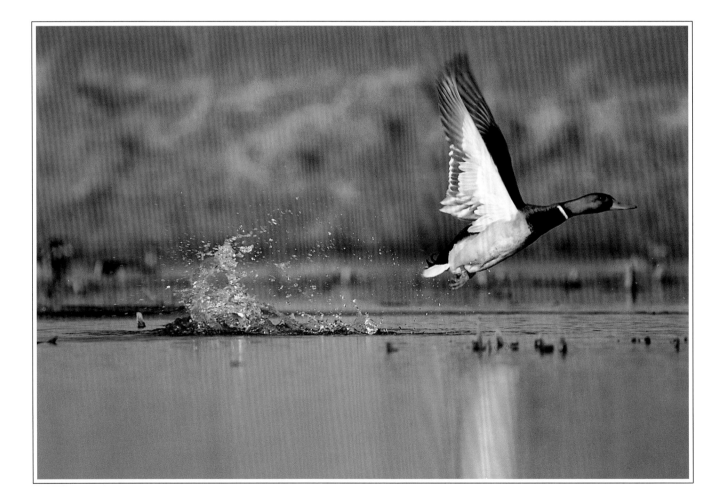

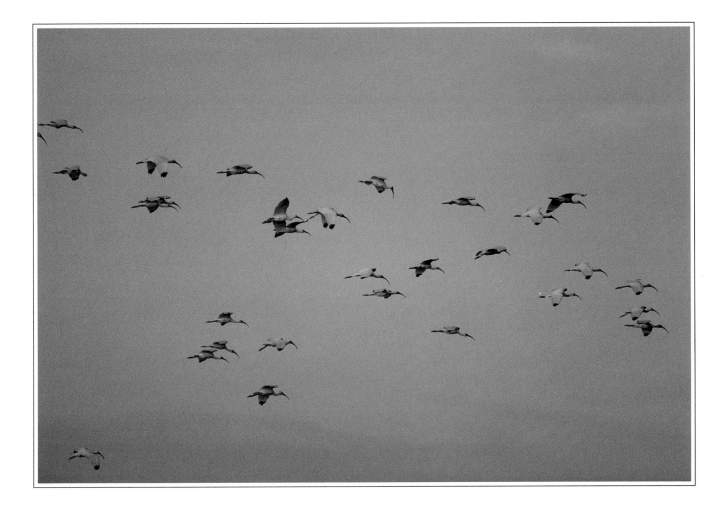

White ibis returning to roost, Everglades National Park, Florida

Every morning and evening white ibis re-trace invisible pathways in the sky that have persisted since before the arrival of humankind. The birds return to roost in the same mangrove swamps, spending the daytime hours elsewhere in backwater sloughs and sawgrass marshes. Less than a century ago they still blackened the sky with their numbers, but those days are gone, the result mainly of shrinking habitat in a region now populated largely by people. The ibis remain locally common. Here a slow shutter speed was necessitated by the low light conditions of evening, forcing Rod to pan the camera in concert with the fast flying birds.

CAMERA
The Old Canon F1

LENS
Canon 500mm f/4.5L

FILM
Kodachrome 64

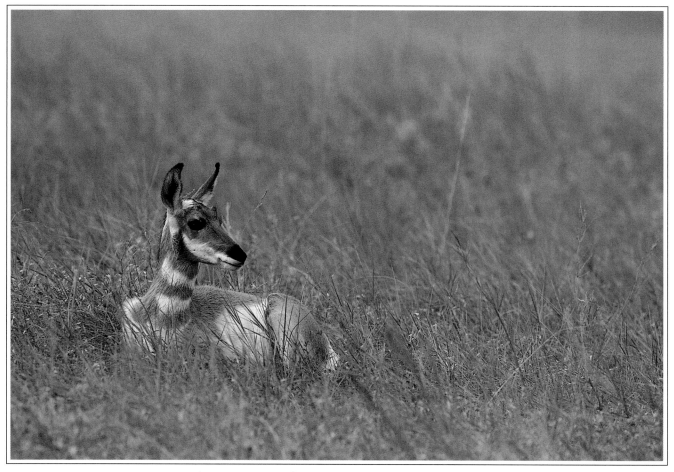

Juvenile male pronghorn, and buck in prime, South Dakota

The relatively short life of a pronghorn antelope begins and ends on the open grasslands. These two males, photographed during the same autumn, are separated in age by only four or five years. One has survived to become the dominant buck for a herd of 15 to 20 does and fawns. The other was probably born in May and is only three or four months old at the time of this photograph. The juvenile shows nubs where horns will develop fully by next year, and it likely has already attempted to practice the mechanics of mating while being physically unable to perform. Ability to mate arrives during the second autumn of a pronghorn's life, but most bucks do not reach breeding prime until the third or fourth autumn. A downhill trend may be evident as early as the sixth season if an animal survives that long.

Pronghorns have made a big comeback in certain portions of the Great Plains. The two shown here were part of a band that roamed a protected area closed to hunting. Rod worked a long time to habituate a group of does and fawns to his presence, and was able to follow them to a daytime bedding ground where the photograph of the juvenile was subsequently taken. The photograph of the buck in prime came about unexpectedly. Several large males had been in the area, traveling back and forth between different sub-groups of grazing does and young. This dominant one may have resented Rod's presence, because it suddenly appeared close behind him, standing still in the late afternoon sun. The buck proceeded to round up the various members of the group and herd them away from the intruder.

CAMERA
Nikon F4

LENS
Nikon 500mm f/4

FILM
Fujichrome Velvia pushed one stop

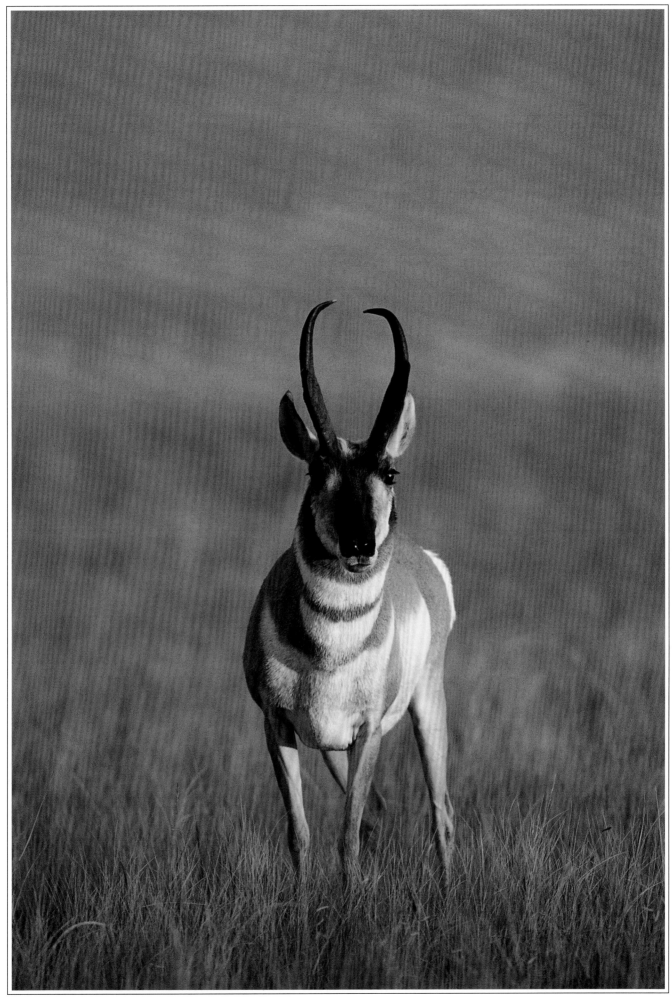

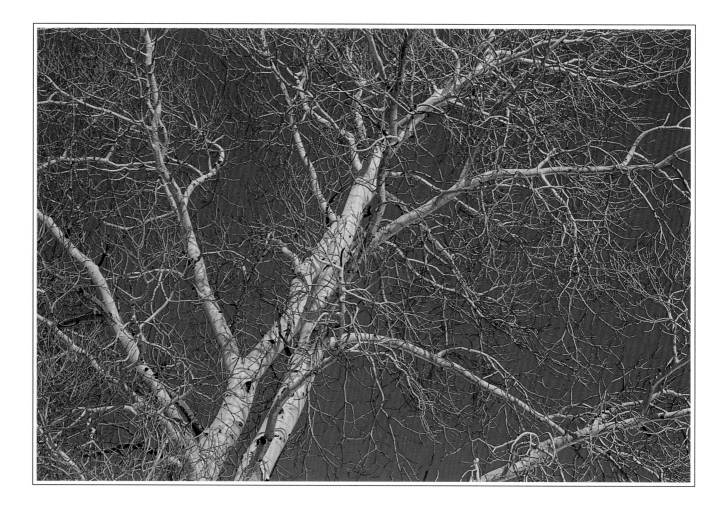

Bare aspen branches, Yellowstone National Park, Wyoming

Seasonal changes happen in great bursts at high elevations or northern latitudes, where the time of growth is compressed in-between long months of winter. The dormant land begins to stir from sleep during the daytime thaws of late February, when a hint of spring is in the air but everything remains securely wrapped in a thick white mantle. The snow first melts from trees like this aspen, signaling that other, more drastic events will soon be set in rapid motion.

CAMERA
Nikon F4

LENS
Nikon 50-135mm f/3.5 Zoom

FILM
Fujichrome Velvia

Maple trees in autumn, Michigan

The bursts of seasonal change culminate in a show of fall color. The various hues are the product of bright pigments left behind and briefly unmasked as trees pull vital resources out of the leaves and transport them down the trunk and into the root system, in preparation for the coming of winter. The leaves are usually jettisoned shortly thereafter. This photograph was taken in the cool of an early October morning, when the sun was just coming up but had not yet burned through a thin veil of mist. Rod was attracted to the bright blaze of red, set against a natural backdrop of various shades of green, yellow and pink. The sharpness of detail shown here can only be obtained when there is no wind rustling the leaves.

CAMERA
Canon EOS 10S

LENS
Canon EOS 90mm f/2.8 Tilt/Shift

FILM
Fujichrome Velvia

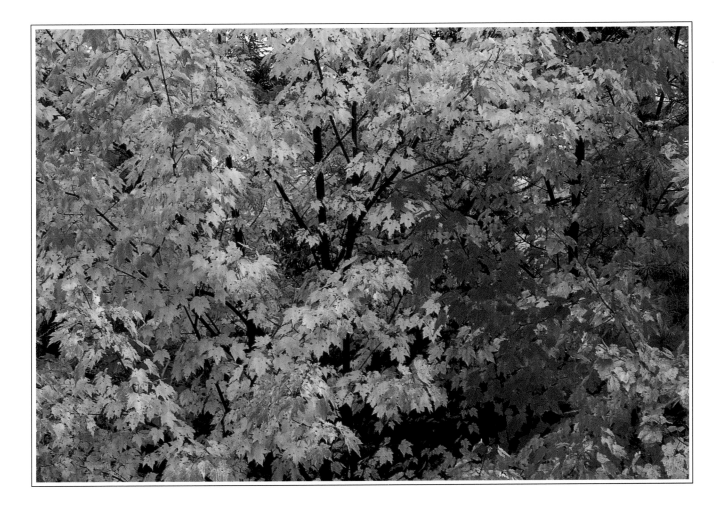

Witch hazel in bloom, Michigan

Witch hazel is easily the last plant to flower each year in Michigan. The small but profuse blossoms appear in early November, at a time when all other flowers, except for a few hardy asters, have long since faded and died. Witch hazel spends the remainder of the year in relative obscurity, growing as a small nondescript tree in the understory or at the edges of dry woodlands. For a short time, however, it becomes an eye-catcher, a splash of yellow in a world dominated by shades of brown and gray.

CAMERA
The Old Canon F1

LENS
Canon 100mm f/4 Macro

FILM
Kodachrome 25

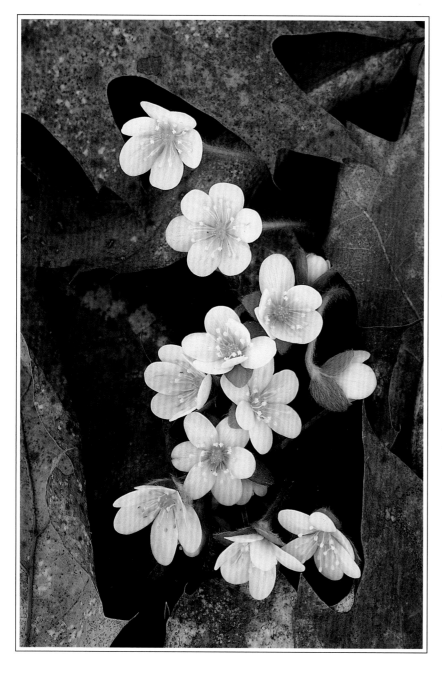

Round-lobed hepatica, Michigan

Hepatica is one of the earliest spring wildflowers in Michigan and elsewhere, and its emergence is a welcome sight. People who take to the woods soon after the last snow has melted away often come upon this pleasing plant, a small but sure sign of impending seasonal changes. The delicate blossoms are frequently seen poking up through the dead leaf litter of autumn past, on stems that appear disproportionately robust because of a dense covering of silvery hairs. Most hepaticas have purple or lavender blossoms, but there is great variability, and pink or white forms are not uncommon.

CAMERA
The Old Canon F1

LENS
Canon 100mm f/4 Macro

FILM
Kodachrome 25

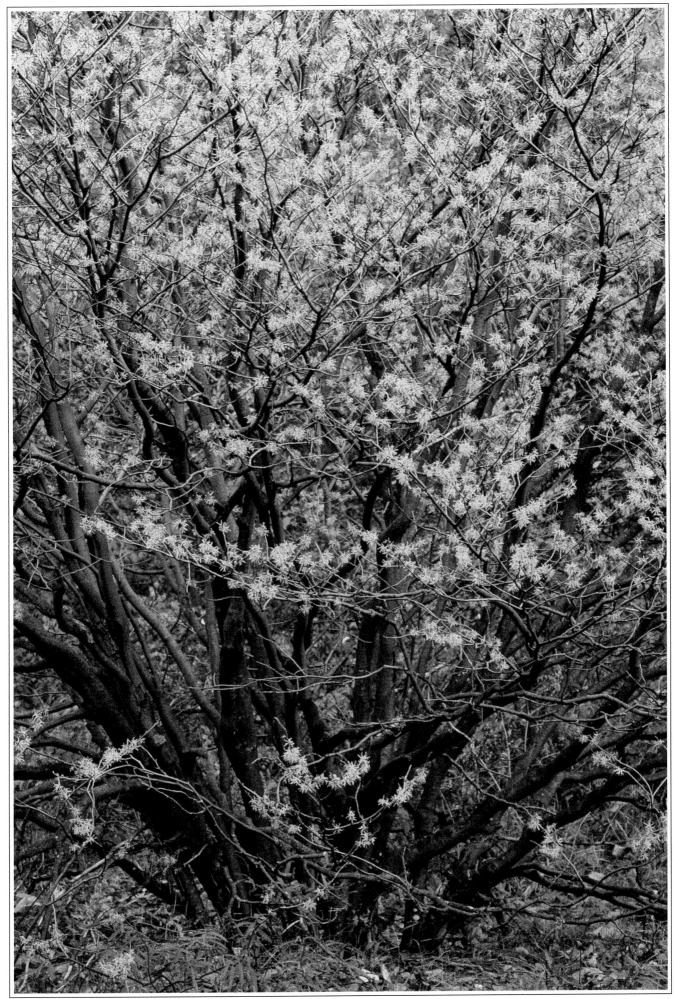

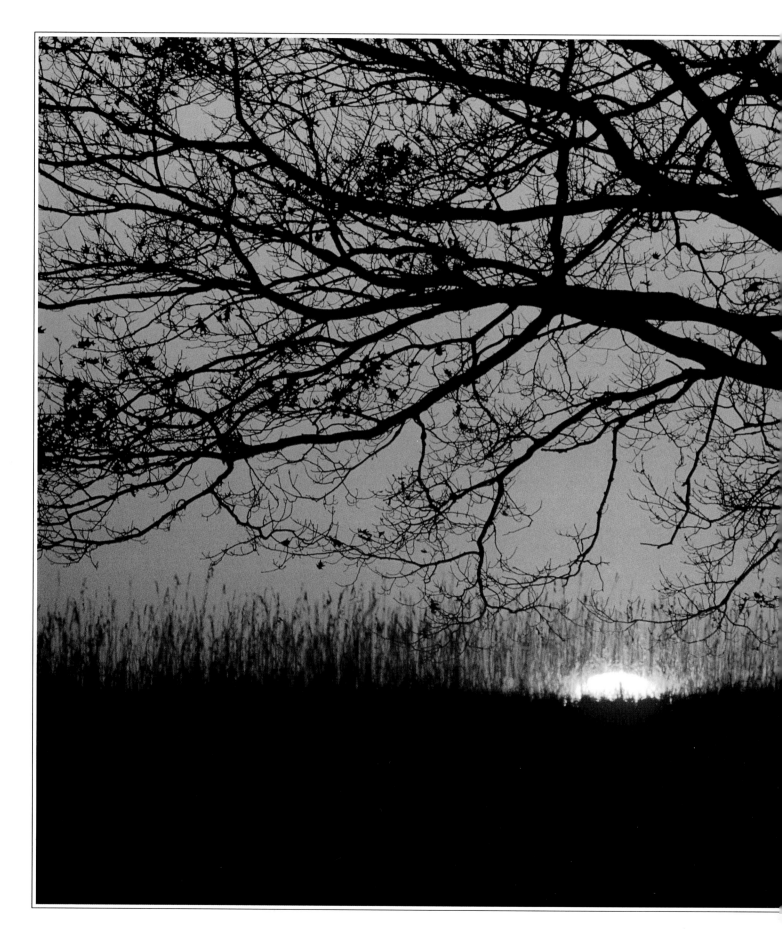

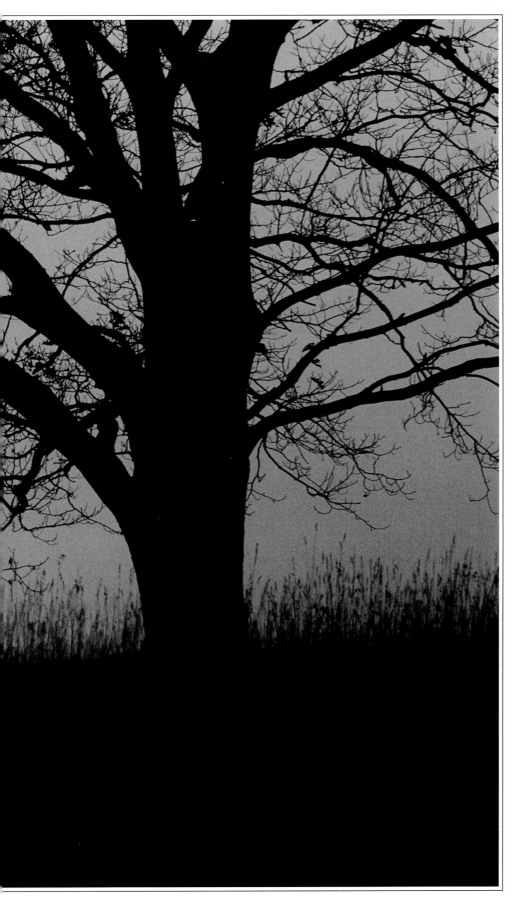

Late autumn sunset, Michigan

The passages of life sometimes circle back, and lead to familiar places that were visited previously. Rod returns to this favorite oak tree throughout all seasons and types of weather. The tree grows in the middle of an old farm field and has low sweeping branches, the result of having lived alone in the open for perhaps a century or more. On this calm evening, autumn was about to fade away, and the air took on a chill that turned out to last until the following spring. The old tree has become a personal yardstick by which Rod measures change, both in the fine details of its branches, which change slowly but surely as the years stretch on, and in his own photographic vision. Rod aims to portray nature in its own setting, under natural conditions, without artificial manipulation of creatures or habitats. The result, it is hoped, are truthful images that invoke a deep appreciation for nature's places. Preservation follows on the heels of appreciation, and it is incumbent upon all of us to watch over and help save these special places.

CAMERA
The Old Canon F1

LENS
Canon 300mm f/4L

FILM
Kodachrome 25

EPILOGUE

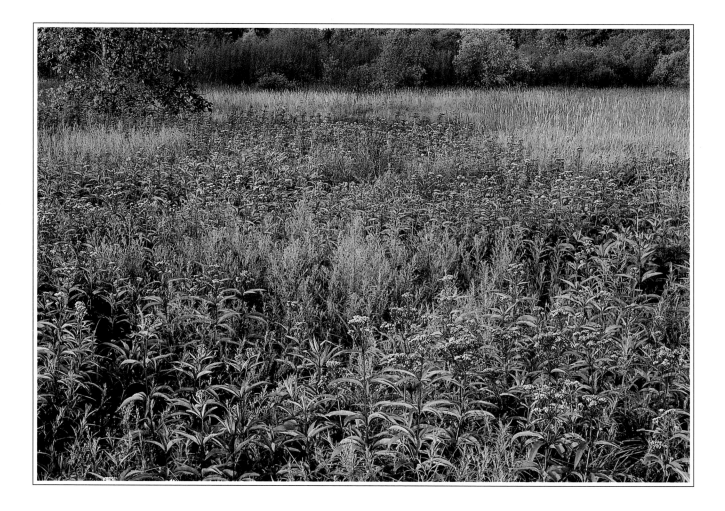

Joe-pye weed meadow, Michigan

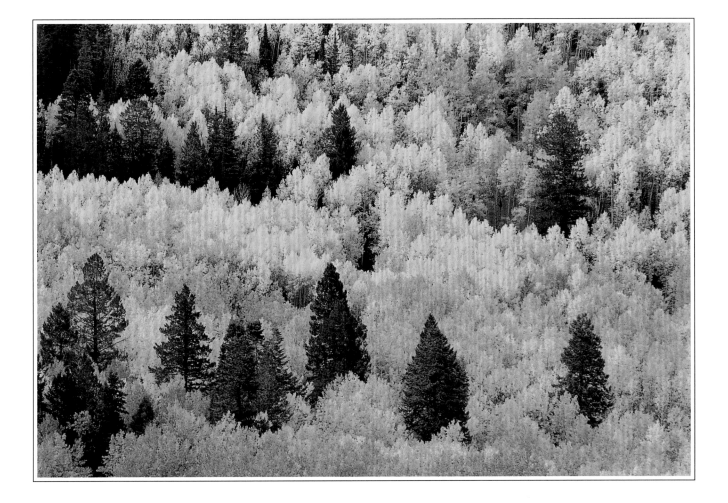

Dixie National Forest in autumn, Utah

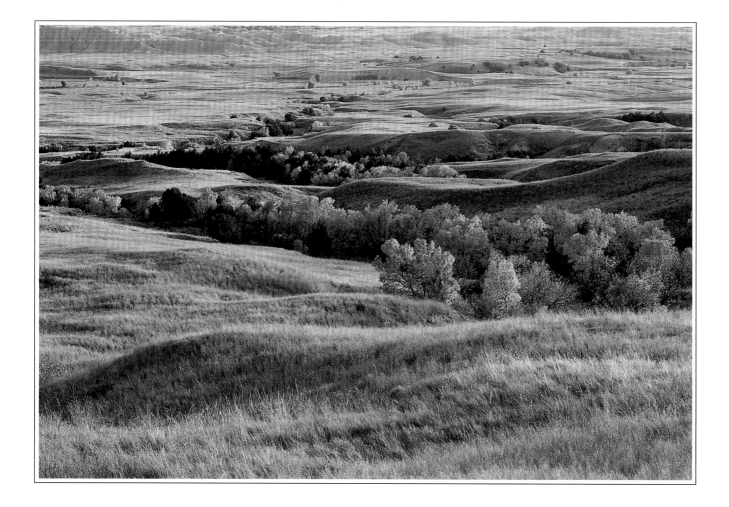

Sage Creek Wilderness, Badlands National Park, South Dakota

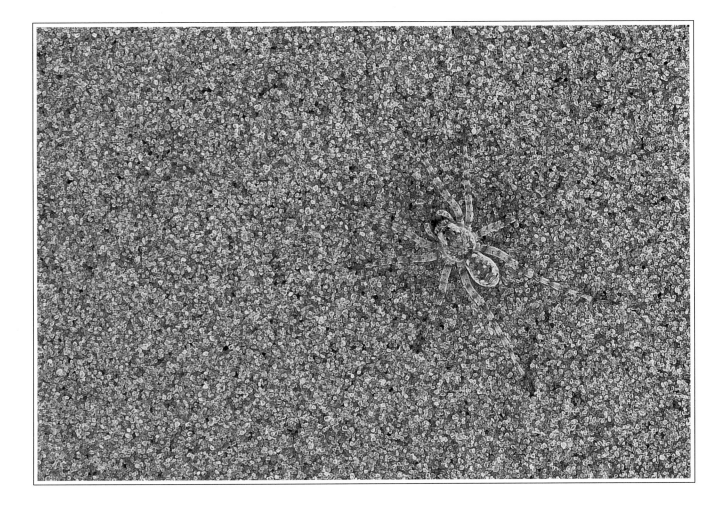

Wolf spider, Pictured Rocks National Lakeshore, Michigan

Shoreline, Lake Superior Provincial Park, Ontario